Jody Frank

## *About the Author*

RAIN PRYOR is an actor, singer, producer, and comedian. She and Richard Pryor are the only father and daughter ever to have headlined at the Comedy Store on Sunset Strip. As a young girl she was a regular on the hit ABC series *Head of the Class*, she starred on the Showtime series *Rude Awakening*, and she has performed in theater productions nationwide. Rain is most proud of the hit one-woman show she wrote and coproduced based on her own life, *Fried Chicken and Latkas*, for which she was nominated for four NAACP Theater Awards and won Best Actress. She is dedicated to the cause of finding a cure for multiple sclerosis, the disease that finally took her father in December 2005. Pryor lives in Baltimore, Maryland.

# JOKES MY FATHER
## NEVER TAUGHT ME

# JOKES MY FATHER
## NEVER TAUGHT ME

LIFE, LOVE, AND LOSS WITH RICHARD PRYOR

# RAIN PRYOR

WITH CATHY CRIMMINS

HARPER**ENTERTAINMENT**

NEW YORK · LONDON · TORONTO · SYDNEY

# HARPER**ENTERTAINMENT**

Photography Credits

Interior photos: Corbis, pages 16, 18, 169, 206; Photofest, pages 20, 80, 83, 84, 94, 103, 121, 127, 154, 172; Jody Frank, pages 186, 188, 189; other photos are courtesy of the author and Shelley R. Bonus.

Photo insert: courtesy of the author and Shelley R. Bonus.

A hardcover edition of this book was published in 2006 by Regan, an imprint of Harper-Collins Publishers.

HarperCollins books may be purchased for educational, business, or sales promotional use. For information please write: Special Markets Department, HarperCollins Publishers, 10 East 53rd Street, New York, NY 10022.

FIRST HARPER PAPERBACK PUBLISHED 2007.

*Designed by Kris Tobiassen*

The Library of Congress has catalogued the hardcover edition as follows:
    Pryor, Rain.
        Jokes my father never taught me : life, love, and loss with Richard Pryor / Rain Pryor with Cathy Crimmins.—1st ed.
           210 p., [16] p. of plates : ill. (some col.) ; 24 cm.
           ISBN-13: 978-0-06-119542-6
           ISBN-10: 0-06-119542-1
           1. Pryor, Rain. 2. Actor—United States—Biography. 3. Pryor, Richard. I. Crimmins, C. E. II. Title.
    PN2287.P76 A3 2006
    792.702'8092—dc22 [B]           2006047952

ISBN: 978-0-06-135097-9 (pbk.)
ISBN-10: 0-06-135097-4 (pbk.)

07 08 09 10 11 WBC/RRD 10 9 8 7 6 5 4 3 2 1

I dedicate this book to the loving memory of my father, Richard Pryor; to my brothers and sisters, whose voices matter; and to my mother, Shelley—just you and me against the world.

# CONTENTS

INTRODUCTION • 1

1. HOME AT LAST • 5

2. INTRODUCING RICHARD PRYOR • 13

3. THE BROKEN HEARTS CLUB • 37

4. WE ARE FAMILY • 59

5. THE GOD OF COMEDY • 75

6. MAN ON FIRE • 93

7. GET OVER IT • 115

8. BEVERLY HILLS HIGH • 131

9. AN ACTOR'S LIFE • 147

10. WEDDING BELLS • 171

11. THE PRISONER • 191

EPILOGUE • 203

ACKNOWLEDGMENTS • 209

# JOKES MY FATHER
## NEVER TAUGHT ME

# INTRODUCTION

*Once upon a time, in a Faraway Land, two hippies were sitting around talking about the rain.*

"Don't say 'hippies,' Rain. It was 1967, and we were Flower Children, not hippies."

"What's the difference?"

"Hippies were dirty. Flower Children were clean and beautiful."

"That's a stretch."

"Just go with it."

"Okay. I'll try."

*Once upon a time, in a Faraway Land, two Flower Children were sitting around talking about the rain. They lived in a Magic Castle—*

"Actually, if you're going to insist on telling the truth, it was a Spanish colonial on Plymouth Street, with brown wall-to-wall shag carpeting. And it's not even there anymore—they tore it down to make room for an office building."

"Can we focus on the two Flower Children for the time being?"

"It's your book."

*The female Flower Child, born in the enchanted borough of Brooklyn, was a beautiful Jewish-American princess, with blond hair and blue eyes.*

"I wasn't a fucking Jewish Princess—I was a radical in the Army of Peace! I left home when I was in high school and shacked up with a bunch of Cuban Marxists!"

*And the male was a very handsome Black Prince, who just happened to grow up in a whorehouse.*

"The motherfucker was handsome—I'll give him that. But *Prince*? I don't think so."

*The Prince and Princess met in a bar and took an instant dislike to each other—*

"Now we're talking, Rainy. If you're going to tell the story, tell it like it is."

*But they overcame their differences, flew to Las Vegas, and got married in a tacky little chapel.*

"Bastard wouldn't even spring for an Elvis impersonator."

*They made love all night and all day, every night and every day, and before long the Jewish Princess was pregnant."*

"Sick as a dog, too."

*Then one rainy afternoon, while the two of them were sitting at home (on the shag carpet), listening to the rain, it suddenly came to her. "Let's call her 'Rain,'" she said.*

*"Who?" he said.*

*"The baby!" she said.*

*And the Black Prince perked right up and his eyes went all wide. "Rain!" he said. "Now that's a good name. I like that name!"*

"You know, I hate to do this to you, but now that I think about it, maybe it wasn't the rain after all. Maybe it was the sprinklers."

"Mom!"

"I'm just trying to be helpful. You said you wanted to tell the truth and nothing but the goddamn truth, and I'm doing my part."

"Well? Was it the sprinklers?"

"No, probably not. If it had been the sprinklers, we would have called you 'Sprinkle.'"

"Great name for a porn star!"

"You know what? It's coming back to me now. It really *was* raining. I remember because the windows were all fogged up, and because your father got to his feet and used his finger to write your name in the glass: R-A-I-N."

"Then what?"

"What do you mean, *Then what?* You *know* what. *Life* happened, and everything went to shit."

"Not everything, Mom."

"No. I guess you're right. Not everything."

"I remember good times, too."

"Yeah, so do I. The motherfucker was crazy, but he was never boring."

No, he certainly wasn't boring. Life with Richard Pryor was one hell of a ride.

# 1.

---

# HOME AT LAST

It was one of those rare Los Angeles days when the ocean fog lifts early and the smog never appears. The baby blue sky sparkles, calm and cloudless, and you can see the sharp outlines of the houses clinging to the Hollywood Hills.

The year was 1973—I was four years old—and my mother and I were in her battered Volvo, winding our way toward those hillside houses. I had no idea where we were going, and my mother wasn't talking.

"Are you going to tell me now?" I said.

"Stop bugging me," she said.

"I just want to know where we're going," I said.

My mother took a deep breath, gave me a dirty look, and exploded: "We're going to meet your father, okay?! Happy now? We're going to meet your motherfucking father."

That was a lot to process for a four-year-old. The language didn't bother me—I was used to it—but I was having trouble getting

my mind around the fact that my father lived only a few miles from our own apartment. "My father lives here?" I asked. "In the same city?"

"Where the fuck did you think he lived? On the motherfucking moon?"

Frankly, that was a possibility. I had heard many stories about my father—most of them pretty unflattering—and I never imagined that some day I would become part of his life. He was a famous comedian, after all, and I'd been given to understand that comedy took precedence over fatherhood. What's more, he happened to be a self-destructive, self-absorbed schmuck, and he wasn't even remotely interested in me. That's what my mother told me, anyway—that and worse. Whenever she talked about him, and she talked about him often, she would work herself into such a frenzy that she would turn red in the face. Her parents, my Jewish grandparents, also talked about him. They didn't curse with quite as much vigor, and they didn't turn red in the face, but they made no secret of their feelings for the crazy Black Prince who had ruined their daughter's life (and, in many ways, their own).

"I'm going to meet my father?" I asked.

"Didn't I just say that?"

"He lives in one of these nice houses?"

"That's right. The son of a bitch lives in a fucking palace, and we live in a dump in the wrong part of Beverly Hills."

"Why is it the wrong part of Beverly Hills?"

"Would you give me a goddamn break already?!"

I didn't understand what she was so upset about. Earlier that afternoon, when we were in the house, preparing to leave, my mother

had seemed excited, if a little nervous. She said we were going "somewhere special," and told me to wash up and put on a nice dress and to *try* to look pretty. When I returned, fully dressed and looking awfully pretty (if I may say so myself), she was still in her jeans, topless, tearing through her closet for just the right thing to wear. I guess she wanted to look pretty, too, but nothing made her happy. I watched her try on one blouse after another, growing increasingly frustrated, until there was a veritable kaleidoscope of blouses piled on the bed. She had practically emptied the closet by this time, so she went back to the bed and sifted through the discards, hoping she had missed something. She tried the purple dashiki again, then the severe black knit sweater with the bell sleeves, but neither of those worked. Finally, she opted for my very favorite: a yellow and red Mexican peasant blouse with embroidered flowers. She buttoned it up, tied up her hair with a red silk scarf, and turned to look at herself in the mirror.

"Motherfucker!" she said.

"What did you say, Mommy?"

"Nothing," she snapped. "Let's go."

We went out into the street and moved toward her old, sad-looking Volvo. She opened the rear door and motioned with her head. "Get in," she said. I did as I was told, and as she strapped me into the backseat, I noticed that her hands were shaking. I wanted to ask her if something was wrong, but she didn't seem like she was in the mood for questions, and I didn't want to make her mad. I hated it when she got mad, and she got mad often. She shut my door, hard, then climbed behind the wheel, started the car, and pulled out into the street.

We rode in silence for a while, each of us alone with our thoughts. The Volvo chugged across Robertson Boulevard, took a right on Sunset, then a sharp left into the winding hills.

When she finally told me that we were going to visit my father, I was more confused than ever. I couldn't believe that my father actually lived in Los Angeles, way up in those lovely hills, just a few miles from our shabby little duplex. I couldn't understand why we had never visited, or, conversely, why he'd never come to see me.

"Did he just move here?" I asked.

"No," she said. "He's always been here."

"Do I look like him?"

"Stop with the fucking questions already!"

I looked out the window again. The houses were unlike any houses I'd ever seen—big rambling places nestled into canyons, only vaguely visible behind trees and walls and tall gates.

The Volvo kept climbing, negotiating one hairpin turn after another, and after what seemed an eternity we reached a gate at the top of the hill. We'd only gone a few miles, but I felt as if I were embarking on a very long voyage, indeed. Mom got out and rang the bell and a Hispanic man appeared a moment later. He opened the gate and waved us through. We made our way up the steep driveway and came to a gravel parking lot that was overflowing with shiny new cars.

Mom got out and I didn't wait for her to come and get me. I unbuckled my seatbelt, opened the door, and stepped out onto the gravel. I was standing near the edge of the property, next to a steep drop. I felt a little dizzy from the ride, and the view of the neighboring canyons was so overwhelmingly magnificent that I found myself holding my breath.

My mother walked around the front of the car and took my hand.

"My head feels twirly," I said.

"Yeah," she said. "Mine, too. The air's thinner up here."

"What does that mean?"

"Never mind," she said. "Come on."

"Where are we going?" I asked.

"I already goddamn told you," she said. "You're going to meet your father."

She led me toward the house and through the front door, which was wide open, and once again she seemed a little nervous. Still, she walked inside like she owned the place, and I followed.

It was quite a place. The walls were hung with gorgeous African paintings and African fabrics, and there were wooden statues, primitive sculptures, and ancient masks in every nook and cranny. The floors were carpeted with zebra skins and tiger rugs, and the sofas were low to the ground and covered with textured pillows. The place felt open and inviting, and clearly everything had been chosen with great care, but there was something a little tacky about the opulence. I didn't know it then, of course, but in some ways my father had re-created the whorehouses of his youth.

"What are you gawking at?" my mother snapped.

"Nothin'. All this pretty stuff."

"Oh yeah," she said, oozing sarcasm. "The man is proud of his Dark Continent roots, but he's about as black as Bill Cosby."

The house was oddly empty, but we heard voices outside, along with the sound of laughter, and we followed them out to the pool. There was a party in full swing. My mother hesitated for a moment, took a deep breath, then marched onward with false

self-confidence. A woman in a lounge chair saw us and watched us approach. She was wearing a skimpy bikini, a then-fashionable Twiggy haircut, and smoking a cigarette. She took a long drag and studied us appraisingly until we reached her side. "Well, well, well," she said, smiling. "You must be Shelley and Rain. Richard is expecting you. I'm Maxine. It's wonderful to meet you." She turned her attention to me. "You're cute as a button," she said. "I have a daughter, Elizabeth. I'm sure you're going to like each other. You want to meet her?"

"I guess so," I said.

"You probably want to meet your daddy first, though," she said, then turned and pointed at a skinny man, sitting on an outdoor divan, surrounded by half a dozen people. He was gesturing with both hands, his motions large and fluid. "You see that handsome man right over there?" Maxine said. "The one holding court? Well, that's your daddy."

I looked at him, then up at my mother. She was staring at Richard, and I didn't see much love in her eyes.

"Go on," Maxine said. "He's waiting to meet you. Been talking about it all day."

My mother took me by the hand and we approached, and I could see she was *really* nervous all of a sudden. That made me a little nervous, too, but as we drew closer my nervousness was replaced by astonishment. Looking at that man was like looking into a mirror. We had the same face—lean, with a sharp, long jawline— and the same dark, penetrating eyes. We even had the same long-fingered hands.

Suddenly, he noticed us. He stopped talking and rested his hands on his knees. "Well, shit," he said. "Can it be? Can it really be?"

I looked up at my mother, towering above me, blond and blue-eyed, then back at my father. His hair was a mass of thick, tight curls, and it seemed to glisten in the afternoon light. It looked a little like a halo, and suddenly I felt happy and confident. That was my daddy. I was home at last, back in the Enchanted Castle, where I belonged.

"Hello, Richard," my mother said with icy detachment.

"Hello, Shelley," he said, but he didn't look at her. He was looking straight at me, only at me—his little princess. "Well, shit," he said. Ain't you somethin'?" He turned and addressed his entourage. "She looks just like me, doesn't she? Ain't denying this one's mine!"

Everyone laughed.

"Hey, people," he said, raising his voice and addressing the entire party. "This is another one of my kids, Rain. Say hi, baby. Now don't be shy, girl—you're a Pryor. Pryors are lots of things, but shy ain't one of them."

I was terrified, but I squeaked out a weak hello.

"Man, you're even prettier than me!" he said. Everyone laughed again, right on cue, and when the laughter died down he motioned for me to come closer. I was a little scared of him, but I was also fascinated, so I went. "Are you really my daddy?" I asked in a small voice.

"Hell yeah!" he said, laughing. "I'm your daddy, all right. Now come on over here and give yo' daddy some sugar. Don't be afraid, baby. I made you."

He reached for me, and suddenly I was in his lap. He kissed my cheek and laughed his big laugh. "Man, ain't you a wonder?! Ain't this girl a wonder? Little Rain Pryor! A regular little look-alike princess! What do you say, people? This is my very own sweet-ass little girl. Ain't she something?!"

He held me tight and kissed me again and I felt like crying, but I'd have been crying with happiness. I was home. I was sitting on my daddy's lap. I had a daddy, just like other little girls, and he was real and he was nice and he was kind to me and he smelled awful good.

Little Rain was home at last.

## 2.

---

# INTRODUCING
# RICHARD PRYOR

My father, Richard Pryor, was married six times to five different women. He had seven kids, and I was one of those kids, but for the first four years of my life I wasn't even sure he existed. He existed, though. Big time. By the time I met my father, at the age of four, it seemed as if the whole world already knew and loved him.

Richard Pryor was a comedian, a famous comedian, with a personal story so unusual that it had already become part of the collective imagination. He was born in Peoria, Illinois, to a prostitute, and he was raised by his grandmother, Mamma, who owned a string of brothels, including the one where Richard's mother worked—on her back, on her side, on her knees, or in any position she was paid to assume.

Richard grew up in those brothels, surrounded by whores, and he remained a big fan of whores and sex for the rest of his life—or for as long as he was able. On Sundays, though, Mamma dragged

him to church, because she wanted him to know that there was more to life than fucking. Not *much* more, maybe. But more.

It was a world of contradiction, but young Richard didn't seem to have a problem with it. During the day, he'd go off to school, like every other kid in the neighborhood, and when classes were over he'd race home and hang with the whores. They all loved little Richard, the madam's grandson, and they showered him with so much affection that it probably ruined him for all the women to come.

Many years later, when I would press my father for details about his childhood, he always talked with great warmth about the whores of his youth. "There wasn't a nicer bunch of women in the entire state," he told me. "And they knew how to make men happy. *Fucking* is what makes a man happy. And a good meal from time to time. But everything else is bullshit."

Young Richard had a favorite whore, of course, and that was his own mother. To hear him tell it, she was the prettiest one in the bunch. She wore the softest silk robes, the smoothest stockings, and the fanciest bustiers. Richard worshiped her, even though she was a temperamental drunk who would disappear for months at a time, but eventually shifted his attention to his grandmother, Marie Carter, the one everyone called *Mamma*. She was a big battleship of a woman, silent and stern, and she was fiercely proud of her whorehouses and her girls. Mamma became a madam back when it was almost impossible for a black woman to attain status of any kind, and her clients loved pussy, so they held her in high regard. These included politicians, lawyers, businessmen, police officers, and just about every man in town who knew a good thing when he saw it. "Most of them were white," she told me years later.

"Including the goddamn honky mayor. But they treated me right and I treated them right and the business kept the family fed—and then some. Hell, the Pryor men were *useless*! Your daddy, Richard— he's the only one who ever amounted to anything. Only one who made something of himself!"

Richard was not a great student, to put it mildly, but Mamma was tough, and he did his best to please her. By the time he was in high school, one of his teachers, Juliette Whittaker, decided he had talent, and she pushed Richard to hone those gifts in a variety of plays and showcases. Richard loved acting, but he lost interest in school and dropped out. He did a short, unproductive stint with the U.S. Army, then returned home and reconnected with Whittaker, who helped him get gigs at a number of local comedy clubs.

In 1960, Richard married Patricia Price, and the following year they had a son, Richard Jr., but the marriage didn't last. In 1963 he left Peoria and hit the Chitlin' Circuit, a consortium of black- owned nightclubs in the Midwest and the South, run by blacks, for blacks.

It was a great training ground for my dad—a black version of the Borscht Belt—but he was itching to play to larger audiences. He wanted to entertain *everyone*, like one of his idols, Bill Cosby. Cosby had been raised in a middle-class family in Philadelphia, and his "safe" humor had made him a crossover hit with mainstream (white) audiences.

Finally, in 1963, ready to take on the world, my dad packed his bags and moved to Greenwich Village.

People liked him from the start. He was a cute, scrawny guy with a rubber face and a congenial attitude, and his shtick covered the usual, inoffensive comic ground: wife, kids, job, commuting,

landlords, and so on. This was the early 1960s, and my dad wasn't blind to what was going on—Vietnam, JFK's assassination, the riots in Watts, the civil rights marches—but race and politics played no part in his routines. He was being cautious, he told me years later, "just trying to keep it light," but he was also making an effort to learn from the more seasoned comics—men like Dick Gregory, Mort Sahl, and George Carlin. Another comic that made a big impression on him was Lenny Bruce, who died in 1966, before Dad ever got a chance to see him perform. "I saw him once on the street, in New York, outside one of the comedy clubs," he told me years

I can't believe how young my dad looks in this photo!

later. "Lenny was busy trying to take a picture of a horse's penis. And don't ask me what the hell *that* was about."

Dad was also making time with the women, including white women, and during this period he fell for Maxine, a whip-smart Jewish gal with whom he had a daughter, Elizabeth, in April 1967. (I met her the day I met my father: she's the one who pointed him out to me out by the pool of his Hollywood Hills home.)

When my father wasn't onstage, or angling to get onstage, or hanging with Maxine, he spent a lot of time watching vintage movies. Back in those days, they still had repertory houses, and you could catch old films on the big screen seven nights a week. Dad worshiped Charlie Chaplin, Buster Keaton, and Harold Lloyd, in that order, and he was especially intrigued by the way Chaplin *moved*. Years later, we used to watch old Chaplin movies together, and when I finally saw my father perform I was startled by some of the physical similarities. As Richard himself told me years later, "I can't dance, but I can *strut*."

In a matter of months, Dad was a fixture at various New York comedy clubs, where his clean-cut, inoffensive material kept getting him compared to Bill Cosby. It played well with integrated audiences, though, and it led to a number of appearances on variety shows—Ed Sullivan, Steve Allen, Jack Paar, Mike Douglas—and to his first big break in television, on Rudy Vallee's *Broadway Showcase*.

"I didn't scare whitey," he told me when I was in my teens. "So I became the Token Negro."

Before long, Dad moved to the West Coast, without Maxine and Elizabeth, lured there by the promise of jobs in film and television. He had been told that black actors were scarce, and it turned out he'd been told right. Shortly after landing in Holly-

wood, he got a small, recurring role on *The Wild, Wild West* and decided to become an actor. He enjoyed getting up onstage and telling jokes, but it didn't compare to the experience of really *inhabiting* a character. He was eager to create his own characters, too, but it was early yet, and he was still experimenting.

In 1967, he was cast in *The Busybody*, his first feature film, a wacky ensemble comedy that put him on the set with some of the great comedians of the day, including Sid Caesar, Bill Dana, Jan Murray, Dom DeLuise, and Ben Blue. The movie didn't win any awards, but it led to a part in *Wild in the Streets*, a bizarre vision of a utopian America where citizens are forced to retire when they turn thirty. I guess the movie was trying to capture society's fear of the counterculture movement, but it is ridiculous on just about every level. My dad, the Token Black, was supposed to symbolize the scary future—the day when NEGROES WOULD BE RUNNING WILD IN THE STREETS! (Hey, it was a paying job, people.)

When he wasn't starring in films, or auditioning for roles, he worked at some of the comedy clubs in and around Hollywood, but found himself growing tired of the same, family-friendly routines. After yet another such appearance, Don Rickles met him backstage and evaluated his performance. "It's amazing how you channel Cosby," he said.

This was the mid-1960s. A lot was happening, culturally and politically, and Dad was still mired in the kind of palatable entertainment that played well on national television. He wanted more, though, and he had begun experimenting with darker comedy,

Opposite: My father in his clean-cut days

developing anecdote-rich monologues about some of the crazy characters that peopled his unusual childhood in Peoria, Illinois. All of them were black characters—winos, drug addicts, homeless people—and they all spoke to the *real* Richard Pryor, the one who knew what was happening out there, in the larger world. Onstage, he was a black man, a funny black man, but deep down he was a Nigger with a capital *N*. An Angry Nigger. He could *pass* as the kind of nigger you could bring home to dinner, but deep inside he was a frustrated nigger with two failed relationships behind him, two kids who didn't know he existed, and a stage life that had

Daddy in *Wild in the Streets*

nothing to do with the real him. Still, what was he supposed to do about it? Mainstream America knew all about the Angry Niggers, and they certainly weren't going to pay to see them onstage.

On the other hand, it was hard to ignore the politics of the day. In 1967, the Love Generation was taking a close look at the Establishment, and not seeing much to like. The answer, according to Harvard professor and LSD enthusiast Timothy Leary, was to *turn on, tune in, and drop out.*

It was also the year that three Apollo astronauts burned to death in their test capsule; the year Muhammad Ali was sentenced to five years in prison for draft evasion; the year Thurgood Marshall became the first black justice on the United States Supreme Court; the year forty thousand antiwar protestors marched on the United Nations; the year hundreds of gay men rioted in Greenwich Village to mourn the passing of Judy Garland; the year of *Sergeant Pepper's Lonely Hearts Club Band* and *Star Trek* and *Hair* and *Laugh-In* and *In the Heat of the Night* and *Guess Who's Coming to Dinner.*

They called 1967 the *Summer of Love,* but there wasn't much love among the rioters in Boston, Buffalo, Newark, Detroit, and Washington, D.C.

Black America was angry, and race was on everybody's mind.

That same year, that wild, angry year, my daddy, Richard Pryor, was busy working on his first solo album, struggling to figure out just who he was and what he wanted to say. He was trying desperately to reinvent himself, and he was taking his first baby steps toward the cutting-edge humor that would eventually define his style—and his life.

While he was working on his album, he got a call from

somebody at the Aladdin Hotel, in Las Vegas. They were reaching out to that Nice Negro, Richard Pryor, and offering him a chance to perform on a very large stage indeed. How could he resist? That's what every stand-up dreamed of: The Strip. The Bright Lights. The Big Time. Success. Respect. *Your Name Here.*

The Aladdin Hotel. Shit! The whole country knew about the Aladdin. Hell, the whole *world* knew about the Aladdin. Just two months earlier, Elvis Presley and Priscilla Beaulieu had made it official at the Aladdin. How could he *not* play the Aladdin?

Finally, the big day arrived. It was September 1967, and summer was still winding down. Daddy walked out onto the stage, a skinny guy in a skinny tie and a gray suit, and he looked out at the audience. Dean Martin was there, right near the front, smiling, expectant. Every seat in the place was taken, sold out, and every ass in every one of those seats was *demanding* to be shaken with laughter. *Come on, funny black man. Make me laugh!*

And Daddy, hell, he just froze.

"What the fuck am I doing here?" he said, right into the microphone, loud and clear, then turned and walked off the stage.

The crowd booed, but he wasn't listening. As he made his way toward the dressing room, the stage manager went nuts. "You get back out there and do your goddamn job, Pryor! This is the Big Time, man. For Christ's sake, this is *Vegas!*"

"Fuck Vegas," Dad said. "Those honky motherfuckers don't know shit about me. They don't know who I am and they don't get half my jokes. Don't talk to me about no 'goddamn job.' This ain't a job. This is my motherfucking life!"

Years later, in his autobiography, *Pryor Convictions*, Richard referred to that moment as his "epiphany." He didn't know exactly

what he wanted to do with his career, or with his life, but he knew what he *didn't* want to do—and what he didn't want to do was more white-bread comedy.

So he went back to Los Angeles, and he found himself sitting in a bar one night, alone, when in walked my mother, Shelley Bonis, in a miniskirt and tall, white-leather boots. "This guy comes up to me, and he's got a huge, Mad Hatter–style watch hanging from his belt, and he asks me what time it is," my mother told me years later. "His watch was the size of an alarm clock, and he was asking *me* for the time. Such chutzpah! I fell for him on the spot."

Mom was no fool, though. She wasn't going to let him know

Mom in her quintessentially '70s glasses

she was interested. So she wandered into the middle of the dance floor, alone, and started to dance. I can't even imagine what my dad was looking at, because when I say *dance*, I mean *dance*.

Back in those days, my mother made a living as a dancer in movies and in television—she was under contract to Columbia Pictures—and she absolutely *loved* to dance. This was the sixties, remember? The era of the go-go girl. Of *Hullabaloo* and *Shivaree* and *Shindig!* Of Perry Como, Andy Williams, Dean Martin. And here was my mother, a woman who liked to dance so much that she even danced on her days off—even danced when she was finished dancing for the day—which was what she happened to be doing just then, in front of my daddy. So, yeah, I can't imagine what Daddy was looking at, but I'm sure it was *hot*.

There was one other thing Shelley had going for her—aside from the blond hair, the blue eyes, and that fantastic dance-honed body—and it became apparent the moment she got off the dance floor. You see, she believed herself to be an African American princess. She wore Afro wigs, talked jive, liked all things black, and felt that God had mistakenly put the soul of a *sistah* into the body of a Jewish girl from Brooklyn.

Richard was staring at her. He went back for more. He was wearing bellbottoms with a wide belt and carrying a small note-book and a pen. The bellbottoms were de rigueur back then, but the pad and pen were unusual.

"I see you like to dance," my father said.

"Yeah. You dance?"

"No, not really," he said. "But I've got *moves*."

She shook her head, gave his outfit the once-over, and asked, "Do you always look this silly?"

"Silly? Ain't nothing silly about me, woman," he said. "I'm a *man*. I ain't got *time* to be silly."

"So what're you writing on that little notepad of yours? You're not trying to steal my dance moves, are you?"

"Dance moves! I'm working on my *act*, girl."

"What kind of act?"

"My comedy act. I'm a comedian."

"Oh, I *thought* that might be you. You were on Ed Sullivan, right?"

"While back."

"I read about you. You're the guy who walked off the stage in Vegas. I dig that."

"You 'dig that'? Now where you comin' from, girl, talkin' the talk. You don't look like no nigger I know. You're not some kind of freaky bitch, are you?"

"No. Just a horse of a different color. Hip to change is all. I call it like I see it, and what I'm saying is, The Man ain't The Man no more—dig?"

"Don't get all political on me, bitch. I know who the fuck I am. I'm a nigger. And I know who the fuck you're not: a nigger."

"You don't know a thing about me, funny man. Not a thing."

Within days she had moved into his house on Laurel Canyon, not far from the heart of Hollywood, and they poured out their respective stories. His, you already know. Hers, well let's just say that Richard Pryor had never met a woman like Shelley Bonis.

Her parents, Herb and Bunny, were a fairly sophisticated show-biz couple. Herb managed the careers of many entertainers, including comedian Danny Kaye, and Bunny was a Brooklyn housewife who managed her nice figure, her makeup, and her perfectly coiffed

hair. When Mr. Kaye moved west, Herb and Bunny followed, and they settled into their new life as a pair of liberal, entertainment industry Jews.

Though maybe not so liberal. . . . When my mother informed them that she had fallen in love with a black man, they freaked out. "People are going to talk," Bunny said. "The world is not ready for this interracial business. You have no idea what you're up against."

"Wait till you meet him, Mom," Shelley replied. "He's absolutely magical."

"Magical schmagical," Bunny said with her Jewish lilt. "I know his kind."

Shelley was furious. *His kind!* To hear this from the mouth of her own liberal mother was more than she could bear. "I never knew I'd been raised by racists," she screamed, and she stormed out of the house.

Later, when Shelley calmed down, they spoke on the phone, and her father tried to explain what he had meant: *Richard was an entertainer. He had a reputation as a ladies' man. He was unreliable.* "And what was that business in Las Vegas—what kind of man walks off the stage like that?" And, finally, yes—the man was *black.* "Do you have any idea what you're up against?" he asked.

"I don't care," Shelley replied. "I love him."

A few weeks later, she brought Richard by the house. It was civil, sort of, but it was a far cry from *Guess Who's Coming to Dinner.*

Herb and Bunny both had serious doubts about the chances that these two could make a life together, and they said so, but Richard remained undeterred. "I love your daughter," he said. "I

love that she's smart, and I love that she believes in me, and I love that she makes me want to reach for the moon."

After that speech, what could they say? Herb gave his blessing, albeit reluctantly, and Bunny sat next to her husband, saying nothing, not trusting herself to say anything.

"I love my daughter with all my heart," Herb said finally. "Please don't hurt her."

"You have nothing to worry about, Mr. Bonis. I love her with all my heart, too."

So off they went to Vegas, to tie the knot in a tacky chapel, and shortly after they got home Herb and Bunny sent out a wedding announcement, with a picture of the happy couple. It must have killed them: Our lovely daughter, with that crazy comedian—right there in black and white, for all the world to see.

"We had no problem with your mother marrying a black man," Bunny explained years later, looking a little *ver klempt*. "But did the neighbors have to know?"

For a few weeks, to hear Mom tell it, she and her African prince were in heaven. They made love all day, every day, and when they weren't making love they collected pet rocks and gave them cute names and engaged them in conversation.

"How you doing this morning, Rocky?"

"Okay, Pebbles. Wanna fuck?"

Mom was so happy she kept pinching herself to make sure she wasn't dreaming. My mother, you see, was an incorrigible romantic, and in those heady early days she was convinced that she had found her soul mate—her magical, missing half.

Dad, on the other hand, was less romantic, and in no time he

was using the marriage as fodder for his comedy routine. "She got me to marry her while we was balling," he told his audiences. "Just as I was about to come, she asked me, 'Richard, will you marry me?' and a moment later I'm crying, 'Yeah, baby! Yeah! Oh *yeah*!'"

Like they say, there's a lot of truth in jokes, and there was plenty of truth in this one. Dad was many things, but he was first and foremost a sexual animal—not surprising for a guy who'd been raised in a whorehouse—so when he started looking around at other women, well, Mom knew the end was near.

The thing is, sex, for my Dad, was pretty much recreational. It was fun, it was a tension reducer, and, no—it didn't have anything to do with love.

In his teens, his *very early* teens, when he got his first taste, the whole world suddenly made perfect sense. My father finally understood why men were willing to pay for it. Hell, he understood why they were willing to *die* for it.

Sex was something of an obsession for him. Pussy, pussy, pussy! My father talked about pussy all the time. But when he used the word, and he used it constantly, it never sounded dirty: "Gotta get me some pussy." "Can't stop thinking about that pussy." "A man can never get enough pussy—and you can quote me on that."

Mom the romantic, on the other hand, thought that sex was an expression of their deep, abiding love, and for a while I guess he let her believe this. He didn't tell her he loved her very often, and he didn't bring her any flowers, but he was great in the sack, and he could be very sweet when he was stoned—which was pretty often. So it worked. For a while.

Mom was also a romantic about politics, and she believed that she and her black prince could literally change the world.

Oddly enough, in some ways, she knew more about black America than he did, and they often got into long discussions about the future of the country. My mother was familiar with the writings of Malcolm X, with Angela Davis, with the Black Panthers, and these conversations went a long way toward politicizing my father. He was still pretty lost at this point—so lost he had walked off the stage at the Aladdin—and he was looking for his next act.

And Mom honestly believed in him. She believed that Dad had the talent and the power to change the world, and that with her help he'd have the political foundation to do it. Those days were probably the best times they ever had, because they were full of promise, but unfortunately they didn't last. Richard was volatile, unpredictable, antiromantic, and downright mean. There was only so much Mom could take, and she was this close to her breaking point. Alas, that's when she discovered she was pregnant.

*Okay, so maybe the marriage isn't falling part. Maybe this is a sign. The marriage is worth fighting for.*

She went home to break the happy news to her parents.

"Don't say anything until there is life!" Grandma Bunny snapped.

This was not exactly the response Mom had been hoping for, and she was outraged. She accused her mother of being a racist and raced off in a huff, swearing that she would never again talk to her fucked-up parents.

She never gave Bunny a chance to explain herself. "I was just being superstitious," she told me years later. "In the Jewish tradition, you're not supposed to mention a birth until after the first trimester. It had nothing to do with race."

My mother went home to Richard, and the marriage continued

to unravel. Still, she believed they would get through it. She had been looking forward to motherhood for many years, and she had waited for the right man to come along, and for a while Richard had been the right man. In her heart, she thought he could become the right man again, so she hung in.

When I think back to what it must have been like for her, I can't even begin to imagine it. There she was, pregnant and miserable, hoping for a happy outcome, and every day was another fight.

"Fuck you!"

"Shut up, you fucking bitch!"

"Eat shit and die, motherfucker!"

"Drop dead!"

Nowadays, parents put a lot of time and energy into having healthy babies, and they often go to ridiculous extremes. They'll coo at them through stethoscopes, crank up the soothing tunes, even read to them—loudly—while they're still in the womb. But that was not the case in my family. I knew the word *motherfucker* before I was born.

When my mother was about six months pregnant, my father returned from a road trip in a red silk shirt, gold chains, high-heeled boots, a brand-new mustache, and an unfamiliar glazed look in his eyes. Now she *knew*—the truth was staring her in the face. Richard was already deeply involved with another woman, and—whoever she was—she had introduced him to some fine new drugs.

He would disappear into the bathroom two or three times a day and emerge minutes later, roaring like a lion. "I am Super Nigger! I am the coolest, funniest nigger the world has ever seen. Nobody can touch this nigger!"

"Wipe your nose, Super Nigger," Mom said. (Now that's funny.)

She eventually found Super Nigger's stash, and she tossed it, and of course all hell broke loose.

"Where is it?"

"Where's what?" she said.

"My powder, baby. What the fuck d'you do with it?"

"Oh, the *powder*, baby. I threw the powder out."

"You *what*?"

"I flushed it down the toilet."

Dad had been violent before, but never as violent as he was on that day. He was throwing punches like a boxer—to her head, to her pregnant stomach—and Mom went down hard. "I should have left him there and then, but I couldn't bring myself to do it," she told me. "I loved the bastard. And you were on your way. And I didn't think I could face my parents."

*We told you so! Didn't we tell you not to marry that crazy nutcase? Didn't we? You should have listened! But did you listen? No, you didn't listen!*

So she stayed. And she believed. And she kept telling herself that things could get better, that once the baby came he would change and they would raise their little family and be happy. But she needed something to make him believe, and one day it came to her.

"Richard, honey—you know that wedding present we got from my parents?"

"What present? They gave us cash."

"That's what I'm talking about. The thirty thousand dollars."

"What about it?"

"Well, you know that movie script you've been working on—that crazy fantasy?"

"It's not a *fantasy*. It's a simple story about a white man who rapes a black woman and is judged by an all-black jury."

"I thought it was called *Uncle Tom's Fairy Tales*."

"It is," he said. "But that doesn't make it any less real. Fairy tales are real, too. I have to get back to work on that script. It's very fucking good."

"Well, baby—that's what I was thinking. I was thinking we'd take my parents' wedding money and make ourselves a movie—our very own movie."

Mom wasn't just blowing smoke, either. She loved the *idea* of the movie. It focused on a Big Theme, racism, and it explored the strained race relations in this great but confused country of ours. The movie had Something to Say. It was an Important Movie.

Dad was Super Nigger, and the more he thought about the movie, the more he felt this was the way to go. Super Nigger was going to change the world, and this was a good place to start. Plus the movie belonged to him. It was his all the way. He was in Complete Control. He was an Artist.

So one fine day he put on his long leather coat and his wide-brimmed pimp hat and drove over to the UCLA campus, in the heart of Westwood. He approached the first two students he saw and asked them to point him in the direction of the film department. The students, who happened to be fledgling filmmakers themselves, recognized Richard and immediately volunteered their services.

Everything fell into place in no time at all. Dad rented a posh house in Beverly Hills, hired an all-student crew, and got to work. For Dad, this meant snorting coke and sipping Courvoisier from

dawn to dusk, and taking breaks now and then to tell everyone that the film sucked. Only one person on the crew could handle his shit, and that was Penelope Spheeris, who went on to direct *Wayne's World* and *The Beverly Hillbillies*, among many other films. I only mention this because there's a lesson here somewhere, and it has something to do with putting up with a lot of shit on the road to success (or something like that, anyway).

In any event, the work continued, on and off, till July 16, 1969, when work stopped for the day so that Mom and Dad could tend to other business. That other business was *me*. I arrived at 11:30 that morning, at the old Cedars Sinai Hospital, in the Los Feliz

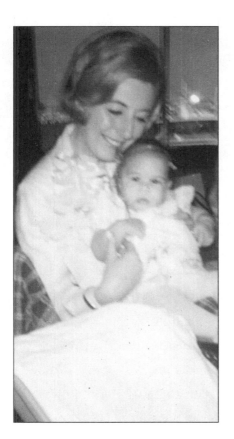

section of Los Angeles, not far from the current site of the Church of Scientology. I am a true Cancer, or Moonchild, not only because I was born in July, but because I exited my mom's womb right as Neil Armstrong, Buzz Aldrin, and Michael Collins were blasting toward the moon.

While Armstrong was taking a small step for man, and a giant step for mankind, Grandma Bunny did him one better by making her way to

Grandma Bunny holding me. At first Mom's side of the family suggested giving me up for adoption, but with my *punim* (pretty face), how could you?

the hospital to take a look at her newborn granddaughter. She actually knew an obstetrician at Cedars—what can I say? She's Jewish—and she had asked him to call her the moment I was born. When the phone rang, she was sitting in front of the TV, watching continuing coverage of Apollo 11.

Herb drove her to the hospital, and they made their way to the maternity ward side by side. It was the first time they had seen my mother since the fight, and they didn't want to say anything about the fight, so they focused on little me. "My, she's black as a berry, isn't she?" Bunny said. "Black as a berry, black as a berry."

Mom was deeply insulted. She immediately assumed that Bunny had hoped for a "more Caucasian" granddaughter, and she said so.

"That's not what I meant," Bunny replied, defending herself. "I was simply making an observation."

The two women quickly made peace—my mom was too exhausted to argue—and the sins of the past were quickly forgotten. After all, this was a healthy child—a blessing! A gift from God!

The truth is, my grandparents were not racists, but they were acutely aware of the problems facing a biracial child in a world that wasn't ready for biracial children. Like good grandparents, they worried. And worrying was in their blood.

My mother, on the other hand, saw my birth as a harbinger of good. As a biracial child, I represented America's bright future. When she looked at me, she envisioned an America where race was a thing of the past. *We are all brothers under the skin.* I know, I know—it sounds a little precious, but this was 1969, the year of Woodstock—the so-called Summer of Love.

Remember the Youngbloods:

*Everybody get together*
*Try to love one another right now*

And Dad *tried*. Sort of. When I was born, he arrived at the hospital with flowers, grinning ear-to-ear, and he showered Mom with kisses. He took a lot of interest in me, too. When he saw the nurses changing my diapers, for example, he noticed a bluish bruise near my lower spine and asked about it. He was told it was called a "Mongolian spot," and that it was a melanin deposit—something fairly common among biracial children. He was over the moon about it. Suddenly he was in full agreement with my mother about the meaning of my birth: *Little Rain was Something Special. Little Rain was gonna change the motherfuckin' world!*

*Special?* I was black and blue from the start. Maybe God was trying to tell me something.

Five days later, when it was time to take me home, Dad didn't show up. Mom waited and waited, then finally asked one of the nurses to call her a cab. When she got home, she found Dad in bed with the housekeeper.

Mom locked herself in the bathroom and wept.

And I'm sure I wept with her.

3.

## THE BROKEN
## HEARTS CLUB

Our little biracial family never recovered from that rocky start.

Mom forgave Dad for sleeping with the housekeeper, which, in my book, defies understanding, but Richard never even apologized for it—which further defies understanding. He was Super Nigger! He didn't owe anybody an apology for anything! *I am the Mother-fuckin' Man!*

To compound matters, Dad was just not into the whole parenting thing. Babies were noisy and sluglike. All they did was eat and shit and cry, and then the whole damn cycle of need would start all over again. His attitude toward me was simple: *I'll come back when she's fun.*

Within weeks, my dad was gone half the night, every night, busily screwing other women. His wife had just given birth, and she was tired and in no mood for sex, but Dad had his *needs*, and there were plenty of fine women in the world who were more than willing to meet those needs. *Let's don't waste all that fine pussy!*

Before long, he was bringing women back to the house, and, on one occasion, stoked on coke, actually begged my mother to take part in a threesome. She demurred, and Daddy went off to enjoy himself à deux.

My mother hung in, though I honestly don't know why. Despite the ongoing abuse, both physical and emotional, she was determined to save her marriage. To this day she can't explain it. Maybe it was love, she told me. Or maybe it was postpartum depression. But they didn't know much about postpartum depression in those days, so she called it love. And God knows she tried to make it work: *No wonder he fucks other women! Look how depressed I am! I better put on my happy face!*

Mom eventually emerged from her funk, turned a blind eye to Dad's continuing bad behavior, and once again became his Number One Fan. They were going to change the world together, Dad, Mom, and little Rain, and they could start by going back to work on *Uncle Tom's Fairy Tales.* Unfortunately, most of the money was gone, blown on women and drugs and booze, and everyone affiliated with the project had drifted away, tired of waiting for wages that never materialized. Only Penelope Spheeris still believed. She continued to work on the film, on the dining room table, parked in front of the Moviola, struggling to give the raw footage shape and coherence. Dad would try to help her from time to time, especially when he was fueled on cocaine, editing and re-editing the scenes until he felt they were "absolutely perfect."

From time to time, his friends would stop by the house, and they'd get high with him, and then they, too, would take a look at the rough footage and make their own crazy suggestions. Poor Penelope: she would try to humor all of them. And poor Mom: she had to

entertain hordes of hangers-on, serving drinks and cooking and cleaning and wiping my butt and playing the role of the happy, dutiful wife/hostess/mother (in that order).

After months of effort, Penelope only had forty minutes of edited footage, none of it very good. It was clear that the project was an unmitigated disaster. This was hard on Richard, but it was even harder on Mom, because the film had been one of her big dreams. It was not only going to change the world, it was going to save her marriage. Now there would be no film, and no world saving, and her marriage was in worse shape than ever.

Dad refused to give up on the movie, however, and he urged Penelope to hang in. They kept looking at the same footage, refusing to let the film defeat them.

One day, Mom came downstairs to find Penelope hunched over the Moviola, red-eyed and exhausted, and Dad sitting nearby, sipping Courvoisier and smoking crack. His crack pipe had become his new best friend.

"I'm sick of this movie and I'm sick of your shit," Mom said. "You have a wife and daughter. It would be nice if you would acknowledge us from time to time."

Dad looked at her, said nothing for a few moments, then stormed to his feet and ran over to the Moviola. He ripped the film out of the bin and started shredding it with his bare hands, and in less than a minute he had managed to destroy six months' worth of work. Penelope looked on in shock, too stunned to say anything.

When Dad was done, he ran outside and climbed into his car, and Mom followed him out into the driveway. As he began pulling away, she jumped onto the hood and held on for dear life. She may well have been sick of his shit, and of the endless abuse, and of

the countless infidelities, but she loved him and didn't want to lose him.

Dad kept driving, with Mom still clinging to the hood, begging him to stop, and she didn't let go until he reached a traffic light on Wilshire Boulevard. She banged on the window, begging him to come home, but the light turned green and he pulled away. My mother watched him through the tears until he was out of sight, then turned around and walked home, crying all the way.

Dad came back the next morning with a gift for her: an expensive fur coat. Mom tried it on and wept some more and forgave him. For a few months, she hung onto the failing marriage as desperately as she had hung onto the hood of his car, but it didn't work. After another round of coke-fueled abuse, both verbal and physical, Dad packed a bag and walked out of our lives.

Mom went to her parents' house, told them the marriage was over, said she really was in no mood to listen to their shit, then left me there and hopped on a plane to New York. She was going to try to figure out what to do with the rest of her life, she said, and she'd let them know when she had some answers.

The next few months were very rough on all of them. Herb and Bunny's family urged my mother to give me up for adoption. They told her that Herb and Bunny didn't have the energy to raise an infant—let alone a biracial one—and that they didn't think she was in any shape to try to raise me on her own. As for Dad, that wouldn't be a problem, because it was obvious he didn't give a shit about his daughter.

There was a period of confusion, to understate the case, with lots of phone calls back and forth, lots of cursing, and lots of crying, and a few months later Mom returned to Los Angeles, bundled me

up, and took me to New York. Within a week, however, we had re-
turned to L.A. Mom pleaded with her parents to take care of me un-
til she got on her feet, there was more cursing and more crying, then
she hopped on a plane and went back to New York to find herself.

I spent the very first Christmas of my life with Bunny and
Herb, which is kind of ironic, since they don't celebrate Christmas,
but they actually went out and bought a Christmas tree for me. "It
was the first Christmas tree I ever had," Bunny told me years later.
"But what could I do? I had a half-goyishe granddaughter. I
couldn't *not* get her a Christmas tree!"

For the first two years of my life, Bunny and Herb were my real
parents, because my own parents were too fucked up to deal with me,
but one fine day my mother came back to Los Angeles, packed my
things, and again took me back to New York with her. She was go-
ing to take another stab at motherhood, even if it killed her.

I can't say she was an unqualified success. There were times when
she simply couldn't cope, trapped in a tiny apartment with a tiny,
mocha-colored child, and occasionally turned to prescription pain-
killers to get by. Sometimes they got her through the day. Sometimes
not. When they didn't, she tended to explode in *Mommie Dearest*-type
rages, and it was all she could do to keep herself from striking me, or,
worse, from tossing me out
the window.

As night fell, she would
pull herself together to go to
work, as a dancer—because

Mom worked as a dancer in New York
after her divorce from my father.
Because of me, it didn't work out.

Jewish girls don't use the word *stripper*—and Miles Davis would come downstairs to babysit. Yes, *that* Miles Davis.

My grandparents helped a little, or tried to, anyway, by sending the occasional check, but Mr. Pryor did absolutely nothing for us, and Mom got tired of asking. She would sooner dance on tables for money than get on her knees and beg the bastard prince for help.

There were other jobs, too—there was a brief period when she did some legitimate dancing, on theater stages and on a number of dance-themed television shows—but she remembers those months as a period of endless struggle and endless humiliation. "Don't ask me for detail," she once told me, in obvious emotional distress. "I'm not talking."

The only constant in my life, back then, anyway, was Miles Davis, who had met my mother a couple of years earlier, through my father, and who was always around to help. I can remember how happy I'd get when I heard his footfalls on the landing, outside our door. I also remember the way he tucked me into my little bed, all snug and warm, and I remember the lullabies he played for me on his trumpet until I fell asleep.

The only other memory that's seared into my brain involves another cultural icon, though admittedly a lesser one: Big Bird. I'm not sure of the circumstances, exactly, but Mom had been working on a show and she met someone who knew someone who knew someone else, and one day I found myself at the studio, with Big Bird towering across the room, just yards away. I was too scared to walk over to say hello to him, but that wasn't the point. I had met Big Bird! My great big yellow hero was real!

In retrospect, I can see that my mother made a genuine effort to

give me a normal childhood, and that much of her pain came from the fact that she was failing me. From time to time, desperate to make me happy, she would forget her promise to herself and call Richard for help, leaving long plaintive messages at his home. He never called back, though. He was too busy finding himself and doing cocaine and fucking women.

At one point, in 1970, he moved to Berkeley and hung out with the so-called Black Pack, a group of African American writers that included Ishmael Reed, Cecil Brown, and David Henderson. He read about Malcolm X, chilled with the brothers, and went to clubs and bars to get a feel for contemporary blacks in contemporary America—an America that was falling far short of the dream.

His political awakening had been a long time coming, but it was finally happening. He had once been accused of being a Bill Cosby clone, but that Richard was no longer in evidence. The *real* Richard Pryor made his debut after that self-imposed exile, and he brought all sorts of new characters with him. These characters cussed and worse, and they talked about misery and despair, and people connected with them and laughed. Richard also began mining his own childhood, the whorehouse years, as it were, until he finally metamorphosed into the real Richard Pryor.

As a father, however, he was a complete washout—and he knew it. In his autobiography, *Pryor Convictions*, he admitted that fatherhood had always struck him as an alien concept. "You know, my attitude about kids and fatherhood was something stupid, something selfish, something that put all of them after my own momentary concerns," he wrote. "I had a hard time thinking about anything but my own needs."

I wasn't the only one he ignored. He had disappeared when

Richard Jr. was born—by rushing off to join the army—and he dis-appeared after Elizabeth's birth, never having bothered to marry her mother, Maxine. Kids and wives—they were so fucking needy, and Richard simply couldn't be bothered.

In 1972, Mom gave up on New York and crawled back to Los Angeles, arriving at Herb and Bunny's place with one suitcase and little me, all wrapped up in a tidy bundle. She had been unable to make it as a dancer, she told her parents, fighting tears, or to find decent work of any kind. She had been forced to sell everything she owned to put food on the table and to pay the rent, and she was dead broke and desperately needed help.

"We told you not to marry that man," Herb said.

"Dad! That's not what I need to hear right now. Show a little compassion."

"You should have listened. But did you listen? No, you didn't listen."

Mom wept, "I need your help, Dad. Rain needs your help."

"Well, I can't help you," her father said. "I've done everything I can."

She was afraid to push him further, because Herb Bonis was himself an angry man, and she'd seen enough of his rage to know she never wanted to see it again. For a few days, the bad feelings notwithstanding, my mother stayed with Herb and Bunny, and by week's end, Herb gave her enough money to move us into a tiny lit-tle apartment not far from their house.

Mom immediately set off to find work. She called some of her old contacts and got a job here and there, but they were few and far between, and she began to come to terms with the fact that she was never going to make it as a dancer. She kept going back to Herb for

help, but one day he reached his limit, and simply exploded. He let her know, in no uncertain terms, and in great detail, that he was seriously disappointed in her, and in the gigantic mess she'd made of her life.

Grandma Bunny grabbed me and whisked me out of the room, shutting the door, but I could still hear him screaming at Mom, and I could hear her trying to defend herself. "Why is Grandpa shouting at Mommy?" I asked, terrified.

"It's nothing," she said. "They're just having a little disagreement."

An hour later, Mom and I were on our way home. From my perch in the backseat, I could see how upset she was.

"Why was Grandpa so angry?" I asked.

"Because he's got a crazy temper," she said. "And sometimes he can't control it." The argument that day was the same argument they'd been having for the past three years: *Nobody told you to marry that sick bastard! You can't take care of yourself and you sure as hell can't take care of this child, so I'm going to tell you again: Give the girl up for adoption!*

I'm sure there were moments when my mother considered it, because I could see it in her eyes. I would go to my room and crawl into bed and put my stuffed animals around me as a line of defense. If anyone came to get me, my animals would protect me. They wouldn't let anything happen. They wouldn't let anyone take me away.

But things deteriorated. Even my mother's friends were urging her to give me up for adoption. She was young, they said. She could start again. Rain would find a nice home and eventually forget these bad times.

Mom didn't listen. She told them that she'd rather die than give up her little girl, and she told them that they didn't understand because they didn't have children of their own. Still, there were times when she *almost* listened. "I remember running around town, looking for work, filling out applications, auditioning, and dragging you with me everywhere," she told me years later. "I was a willowy blonde, and there I was with my little girl, cute as a button but black as can be. I might as well have had a T-shirt made up: YES, I FUCKED A BLACK MAN."

She got grief from both ends. The whites seldom made comments—they could destroy her with a withering look—but the blacks tended to be pretty vocal. My mother remembered one humiliating encounter in particular. "Hey, bitch," a black woman snapped, "you're the reason our men ain't home! You got 'em chasing your white asses!"

On another occasion, a group of generous friends invited Mom to drive across the border with them into Mexico, to relax on the beach for a couple of days. She had fun, and she felt as if she was actually on a real vacation, but on the way back to the States they were stopped by border guards. "Who is this child?" one of the men asked her. "She's obviously not yours."

"Yes, she is," my mother explained. She was trying to remain calm, even though this man was humiliating her in front of her friends. "His father is black. He's an entertainer. Maybe you've heard of him. His name is Richard Pryor."

"I never heard of no Richard Pryor," the guard replied. "This child isn't coming across the border without a birth certificate."

"But I have my passport," she protested.

"Ma'am, you're not the problem. This girl is the problem."

"I thought children traveled on their parents' passports."

"Not this child."

My mother and I had to spend an extra night in Mexico, in a fleabag motel in Tijuana, and the next day one of her friends returned with my birth certificate. She wept all night. And in the morning she got herself together and pulled my hair hard. She was angry.

"I'm sorry," she said, watching me cower in a corner. "I don't know why I did that." Then she took a deep breath and hollered: "No, that's a lie. I do know why I did it. I did it because my fucking life is miserable, and because you're not making it any easier!"

My mother had a little bit of her father in her. She, too, was prone to sudden rages, and for years afterward I was guided by a single principle: *I have to be a good little girl. If I'm a bad little girl, Mommy will get mad, and Mommy will get mad at me.*

By the time I was four, my guiding principle not withstanding, I had turned into a complete smartass. If she was going to be mean to me, if she was going to tell me I ruined her life, well—I'd be mean right back, and I'd do my level best to *really* ruin her life.

I talked back. I spilled my drinks deliberately. I threw food. I would scream if I didn't get my way. I humiliated her in public by saying—at the top of my voice—that she was not my mother.

My petulance only made my mother angrier every time I behaved badly, which was often. She would behave as if she wished I'd never been born, and follow it up with a heartfelt apology. That's the only time I felt she loved me, to be honest—when she was drying my tears. Maybe that's why I misbehaved. I invited her anger because good things happened when it ended. When it ended, I knew she genuinely loved me.

Of course, there were times when I was punished for no reason whatsoever. Once, for example, in the middle of the night, she woke me up and dragged me out of bed and marched me into the bathroom. "You take a dump and you don't have the decency to flush the toilet!" she screamed.

I protested, insisting that I'd flushed it, that it wasn't my fault, but she wasn't listening—and she didn't believe me. She insisted I clean the toilet right then and there, and handed me a brush with which to do the job.

She shut the door on her way out, and I stood there for a minute or two, sniffling, then I fell to my knees and got to work.

Early in 1973, with my fourth birthday just months away, Herb and Bunny finally decided that they couldn't bear to stand by while Mom and I struggled. They sent Mom a check, and not long afterward they invited us to come visit them at home.

The moment I walked in, they were all over me. I don't know what it was—Jewish guilt, maybe?—but from that day on everything changed. I think they suddenly became aware of me as a living, breathing person, as a little girl with a personality of her very own. They had once urged my mother to give me up for adoption, true, but they were well beyond that now. Now I was a real person, a little girl who smiled, talked, laughed at Herb's bad jokes, and even praised Bunny's cooking. How could they resist?

That was the beginning of a brief period of normalcy for me. I was a kid, and I began to behave like a kid. And mom—with the burden somewhat lifted—began to behave more like a mom.

She took me to see *Mary Poppins* at the Fairfax Theater one day, just around the corner from our place, and afterward she bought me a little Mary Poppins umbrella and a straw hat. When we got home,

I walked into my bedroom, emptied my toy chest, and tried to magically "snap" everything back inside, as Mary Poppins had done in the movie. When that didn't work, I decided I could fly, like Mary Poppins, and I stepped onto the window ledge with my hat and my umbrella. Mom walked into my room at that very moment, and literally yanked me back inside. "My God," she said. "What are you doing, Rain?!"

"I'm not Rain," I said. "I'm Mary Poppins."

Mom sighed, and pulled herself together. "Let me tell you a little something about movies, honey. Things happen in the movies that don't happen in real life. Mary Poppins is an actor. Mary Poppins can't fly."

It was strange. Part of me obviously needed to believe that there was a whole other world out there where people were capable of magically disappearing.

"She really can't fly?" I asked.

"No," she said. "She can't fly."

I wish she hadn't broken it to me so abruptly. I was a kid. I wanted to believe. My mother must have seen how disappointed I was. She took me in her arms and held me close.

"I love you so much," she said. "I hope you know that. I'm doing the best I can, and I know I'm not perfect, but I promise I'm going to try harder."

I don't know whether that incident triggered anything for her, but shortly thereafter she decided to try to make contact with Richard. They had a little girl together, and she thought it was high time he got to know her.

As for me, I knew I had a father, not because anyone spoke to me about him, but because they spoke about him in my presence. His

career was very much on its way. In 1971, he taped a successful concert, *Richard Pryor: Live & Smokin'*, and that led to lots of jobs in film and television. He'd been in *The Phynx* and *Dynamite Chicken*, he had a dramatic role in *Lady Sings the Blues*, and in 1973 he had parts in three films: *Hit*, *Wattstax*, and *The Mack*. He was also making a name for himself in television, as both an actor and a writer. He worked on *Sanford and Son* and on *The Flip Wilson Show*, and in 1973 he worked on *The Lily Tomlin Special*, a job that got him his very first Emmy.

Of course, I didn't hear about any of this. Mostly I heard that he was a scoundrel, and worse, and *how could any decent person ignore a lovely little girl like Rain?* When my mother spoke about him to her parents, in front of me, her two favorite words were "genius" and "narcissist." And when we left their house, and were driving home, she was sometimes so worked up that she would curse him as she negotiated the streets of the city. "That no good motherfucker! Making money left and right and he *still* doesn't lift a finger to help us. That son of a bitch! After everything I did for him! Hell, if it wasn't for me, he wouldn't know who Malcolm X *was*! He never would have gone north to Oakland to hang with his *brothers*. He'd still be Bill Cosby Junior! Motherfucker would be *nothing* without me!"

The fact is, in some ways she really *was* responsible for his political awakening, having met him at a time when he had lost his way both personally and professionally. To this day, I genuinely believe that my mother pointed my father in the right direction, and that her influence helped shape the comedian he became.

She didn't resent his success, and she wasn't looking for gratitude, but she certainly resented his steadfast refusal to help us out. She had called him for help when she was in New York, hitting rock

bottom, and he made promises he never kept. And in 1973 she began to call him again. I don't know what it was, exactly, and I'm not sure she did either. But I think that the reconciliation with her own parents had something to do with it. It helped her come to terms with the fact that Richard was family, and that families tended to be a little crazy, but that didn't diminish their importance.

Richard wasn't thinking about family, though. Richard thought first and foremost about himself. Shelley would call, and he wouldn't take her calls, and whenever she managed to get through he was usually a complete mess. "It seemed like he was always stoned," she told me. "I don't know how he managed to stay stoned and still succeed the way he was succeeding. It was a goddamn miracle. Someone was watching over that motherfucker!"

Nobody was watching over my mother, though, and it hurt. She was a proud woman, but she was forced to swallow her pride.

"Don't you want to meet your daughter?"

"I don't know. I guess."

"She looks just like you, Richard."

"I'm not sure that's a good thing."

"Come on. Stop fucking around. Invite us over to the house."

There was a long pause. "Okay," he said finally. "I'm having a few people over Saturday. Come on up, the both of yous. And tell her to bring her bathing suit."

This is where we came in—this is where my story began. This was the day we made our way up those long, twisty roads high above the Sunset Strip, and eventually found ourselves poolside at my father's magnificent house. I was only four, and to me the place looked like a palace. And even in retrospect, I guess it *was* a palace—especially when you compared it to the little place Mom and I called

home. You could see most of Hollywood from up there, and all the way downtown, and—on a clear day—you could see past Santa Monica, all the way to the Pacific Ocean.

I didn't know any of the people at that party, but in time I got to know most of them. They were the usual crowd. Actors. Directors. Writers. Producers. Agents. Lawyers. And beautiful women. Always lots of beautiful women. Some ex-girlfriends among them. Ex-wives, even. And future girlfriends and future wives. Future ex-wives, too.

I noticed the booze, too, which flowed endlessly, and the drugs, always in ample supply, and out in the open, for everyone to see. You didn't have to hide in the restroom in those days, you did your thing and you did it with pride. At Dad's house, anyway. *Don't give a fuck about what them kids see. This is about me, motherfucker.*

Man! Hollywood. What a town. Dad was enjoying all the trappings of success, and then some, and the hangers-on were enjoying it, too. That's not to say there weren't some nice people around, because there were, and many of them were actually quite likable. Some of them were just as successful as he was, and some were even more successful. And then there were those who had worked for a while, maybe last year, or maybe the year before, and who had believed the party would never end. But the party ended, and it stayed ended, so they came to Dad's place and partied and talked about all of the great things they had in the pipeline, most of them imaginary.

Hollywood is a cruel place, and no one feels it more acutely than the people who've tasted success. If you're making it, you think you're going to make it forever, but that's not the way it works. For every successful actor, writer, or director, there are five thousand begging

for work. I was four years old. I was a long way from understanding any of this, but my time would come.

I was in my Daddy's lap that first day, and he was kissing me and laughing his big, raucous laugh. "Man, ain't you a wonder?! What do you say, people? This is my very own sweet-ass little girl. Ain't she something?!"

A few minutes later, though, Dad's interest began to wane. He gestured vaguely and some woman appeared and whisked me away. She took me into the house and I changed into my bathing suit and was escorted out to the pool.

A lovely mocha-colored girl with ringlets of hair was looking up at me from the middle of the pool, treading water. It was Maxine's daughter, Elizabeth.

"You coming in?" she asked.

"I guess," I said.

"Don't you know how to swim?"

"Uh-huh. My grandparents taught me."

"Well come on in. We can stay in the shallow end if you want."

I dipped my toe in the water and slowly made my way down the steps.

"My name is Elizabeth Pryor," she said.

"That's my name, too."

"Elizabeth?"

"No, silly! *Rain.* Rain Pryor."

"That man over there," she said, pointing at Dad, "the one surrounded by all those people. That's my daddy."

"That's my daddy, too!" I said.

"Well, then, I guess that makes us sisters. Hi, sister!"

"Hi!"

"Where's your mommy?"

I pointed to Shelley, hanging out with the rest of the adults, making the scene. "That one," I said. "That one there."

I waved, and Elizabeth waved, too, and Mom came over and smiled down at us. "Hello, there," she said, sounding like a normal mother. "You must be Elizabeth. You are so pretty. Isn't she pretty, Rain?"

"Yes," I said. "She sure is."

Before the day was over, Elizabeth and I had bonded—and the friendship has lasted for over three decades now. Elizabeth was six, I was four, and she took it upon herself to take care of me. She was the alpha female. She showed me around the house and ran me ragged from one place to the next, negotiating the various cliques: the men sitting at the dining table, snorting coke. The ones by the pool, sharing a crack pipe. The mellow foursome in the living room, passing a bong.

I don't remember who all was there, except for one woman, who was introduced to me as Daddy's girlfriend. This was a foreign concept to me—my daddy had a girlfriend?—but I got used to it in due course. This was the nonmarrying period in Dad's life. With three kids and two ex-wives behind him, he wasn't in any hurry to tie the knot again.

I remember asking the Girlfriend for a glass of milk, and she gave me a harsh look and said, "*Please*. I didn't hear a *please*."

"Please," I said.

"Don't your mothers teach you any manners?" she said, addressing both me and Elizabeth. "I'm gong to have to talk to Richard about you two. Little girls need to learn good manners."

That was about the only glitch in an otherwise perfect after-
noon. The party never seemed to end. No one was telling me what
to do. No one was angry with me.

And new people kept coming by the house. Before long I met
Richard Jr., my half-brother, who was ten years old and a little too
superior to be playing with us girls. I also met someone called Re-
nee, who was even older than Richard Jr., and who might or might
not have been another one of Dad's kids.

And I met Mamma, my great-grandmother, who was simultane-
ously wonderful, scary, and stern. This was Richard's grandmother,
the one who ran the whorehouse, the woman who raised him, and—
from what I could tell—the only woman he feared and respected. I
liked her right away, and I especially liked what she said about my
own mother, whom she was meeting for the first time: "I like that
Shelley. She not only pretty, she *smart*, and Richard tells me she
knows how to cook up a pot of greens. I can't say I much like these
other women, though. Hell, most of them are nothing but trouble,
especially the white ones. But not your mother. She okay in my book."

When the day began drawing to a close—after hours of swim-
ming, after eating barbecue, after gorging myself on ice cream and
cookies—my mother helped me out of my bathing suit and back
into my clothes. She took my pruney hands in hers and looked me
in the eye. "I'll see you tomorrow, Rainy."

"What do you mean?" I said.

"You're going to spend the night with your daddy."

"No," I said. "Please don't leave me here. I want to go home
with you."

"Rain, don't make trouble. Your daddy wants to get to know
you. You'll be fine here for one night."

I began to cry. I screamed. I tugged at her arms.

"Please don't leave me here, Mommy! Please! I didn't do anything wrong. I'll be a good girl, I promise."

"Stop it," she yelled. "You stop it right now! You're spending the night with your father, whether you want to or not, so man up, girl!"

Richard came over to see if he could help. I could tell he felt kind of bad. He'd just met me for the first time, and I didn't want to spend the night at his house. But what did he expect? I was just a little kid.

"Come on, baby," he said. "Stop crying. I ain't gonna bite ya. I'm yo' daddy."

My mother turned to look at him, her face suddenly transformed by rage. "You see, motherfucker? This is the shit that happens when you ignore us for four years. Now it's your turn, so fucking deal with it!"

She turned around, stormed out of the room, and in my little heart I was sure I would never see her again.

I listened to her fading footfalls and tried to run after her, but Richard grabbed my arm and turned me round to face him. "Come on, now!"

"Let me go! Please let me go! I want my mommy!"

"Now listen here, girl," he said. "You're my child, too. And, well—shit. I'm not too good with all this crying business, so it would sure help this old dude if you stopped right the fuck now."

I tried to suck it up, but I was still whimpering.

"And I can't be all that bad now, can I? I mean, look at me—I'm just as funny looking as you are!"

I laughed and managed to stop crying, and suddenly I felt

exhausted. Richard picked me up and carried me into one of the guest rooms. Mom had laid my pajamas out on the bed, and I turned my back to him and put them on.

"I'm glad I finally met you, girl."

"I'm glad I met you, too."

"I hope we get to see a lot more of each other in the future."

"Me, too," I said.

I crawled under the covers.

"Good night," he said.

"Good night."

He turned out the light and left the room and I drifted off to sleep, but a short time later I heard noises down the hall. I remembered that I was in a strange house, without my mother, and with a father I'd only just met that afternoon. The noises frightened me, so I climbed out of bed and went off to look for an adult.

I found my way into my father's room and saw him in bed, naked, on top of a blond woman. He looked up and saw me, and I ran back to my room and jumped under the covers, shaking with fear. A moment later, he walked inside and hit the light.

"Rainy?"

I peered out from under the covers. He had a towel wrapped around his waist, and he approached and sat next to me on the bed. "How you doing, girl?" he asked. "What just happened now?"

"What do you mean?"

"Why'd you come running into my room?"

"I don't know. I heard noises. They scared me."

"Why were you scared?"

"I thought maybe somebody was hurting you."

"No, baby," he said, laughing. "Nobody was hurting me. I was

fucking. That's what grown-ups do, they fuck." From his tone, he could have been telling me a bedtime story. "Yep, fucking. That's what we folks do. Sometimes when we fuck, we make strange noises—*ooh, ah, ah, yes, don't stop, baby*—sort of like that. But it's only because we're having fun." He screwed up his face, made more funny noises, and tickled me and made me laugh.

"Those are feel-good sounds, baby," he explained. "Someday you're going to make those sounds, too."

"That's gross!"

"It's not gross, Rainy. It's fun. And it's necessary. That's how babies get made. By fucking. And that's about the only thing people are good at: fucking."

"Fucking," I repeated. I imagine the word must have sounded odd on my lips, because he laughed. Then he leaned close and kissed me on the cheek. "Now get your black ass back to sleep, girl."

He left and I pulled the covers over my head, but I had a hard time getting to sleep. I kept thinking about what he'd told me. People fucked. They made funny sounds, and when they were finished fucking and making sounds they had babies. Fucking was funny!

In the morning, my mother came to pick me up.

"People fuck and make funny noises and then babies come," I informed her.

"Really," she said. "That's fucking fascinating. I'm so glad you and your father had a little talk."

"He was making noises," I said. "I was worried. But he said I didn't need to worry. He was fucking and having fun!"

"That is fucking great," my mother said, but I didn't catch the irony.

## 4.

# WE ARE FAMILY

After that first visit to my father's house, my life changed in dramatic ways. I became a frequent visitor to Richard's place, getting to know him better, bonding with my half sister Elizabeth, and bonding with Mamma, and suddenly I felt that I had a big, wonderful family.

I also started seeing more of my grandparents, who were pleased that my father was finally taking an interest in me, and who apparently saw changes in both my mother and myself.

They lived in Sherman Oaks at the time, a twenty-minute drive from Beverly Hills, and the summer before I started kindergarten, I spent more time at their place than I did at my Mom's. I didn't know it then, of course, but they had a typical middle-class Jewish household, and I owe at least half of my schizophrenic identity to my grandparents. Herb would tell stories about his showbiz clients, chewing on his omnipresent cigar, and laughing at the memories, and Bunny would ask me to help her in the kitchen, shuffling along

in her feathery slippers and introducing me to recipes that went back to the old days in the Eastern European shtetls. She made a mean brisket, and world-class kugel, latkes, and tzimmes. Thanks to Bunny, I can cook Jewish food with the best of them, and it mixes surprisingly well with collard greens and ribs. (In my book, anyway.)

The house was noisy, mostly because Bunny and Herb were constantly yelling and picking fights, but that was nothing new to me, and I figured they had fun when the day was over, and fucked—like regular adults.

Grandpa Herb strikes a pose in Los Angeles's La Cienega Park.

They called me Rainflower, and—despite the constant arguments—actually gave me a real sense of domesticity. This is what a stable home looked like. Good people, family stories, home-cooked meals, regular bedtimes—all peppered with the colorful Yiddish expressions that I've made my own: "Fuckin' oy!" I'll say. Or, "He's a meshugene mutherfucker!"

From my grandparents, I learned the rhythm of Jewish life. The lighting of the candles on Friday night. The meaning of the Sabbath. How to get what you want by being a spoiled Jewish princess. But seriously: they came to love me, not despite my mixed ethnicity, but *because* of it. We had gotten off to a rocky start, but in time they made me feel like there was no one like me in the whole wide world. I was a black Jewish American princess.

Life with Mom was also somewhat improved, but only marginally. We were living in a small apartment in a Spanish-style fourplex, and we were forever beset by bill collectors. *I can't afford this, and I can't af- ford that, and if you really want that fucking dress you should ask your motherfucking father.*

Still, it wasn't all bad, the

In front of our Beverly Hills apartment

shag carpeting notwithstanding. The place was quiet, and the neighborhood was pleasant enough—for the nonglitzy part of town—and Mom had tried to make it warm and cozy. There were items she had picked up in Mexico—vases, tapestries, primitive paintings—and she owned several Japanese lithographs, which gave the apartment a peaceful air. For some strange reason she also had a framed photograph of Bela Lugosi, the actor best known for playing Count Dracula. I shuddered every time I passed it, because Lugosi's piercing eyes seemed to follow me everywhere I went.

The biggest change in my life, of course, was my daddy, whom I visited frequently. Suddenly I had a family—a large, strange, interesting, *different* sort of family—and the world felt safer and more promising.

By the time I started kindergarten, I felt almost like a normal girl. I had a mother and father, just like the rest of the kids, and they were divorced, just like *most* of the rest of the kids, and I wasn't really all that different from everybody else. Well okay, that's not entirely accurate. I was black and I was Jewish, and I was pretty sure there were others like me in the world, but I didn't know any of them. I didn't want to be different, though. I wanted to fit in; to be loved; to be just like all the other kids. So I worked at it. I tried to please everybody. I became a regular chameleon, changing to suit any situation. *I can be anything you want me to be!*

In later years, when I turned to acting, I found it easy to adopt the mannerisms and the characteristics of the people around me, which served me well. But back then, it was tough: I had no idea who I was, or who I was *supposed* to be, and there were times when I felt that there was no *me* there.

Later, I could joke about this—I would tell people that I was

black and proud of it, but because I was Jewish I felt a little guilty about it, too—but it wasn't all that funny, and race remains an issue for me to this day. On good days, I feel like the world accepts me; on bad days, I feel as if I'm on my own, destined to be an outsider forever.

I never had that problem around my family, though. I was free to be myself—whatever that was! And I was too busy becoming a normal kid to worry about it.

As an only child, I had often dreamed of finding out that I was

Here I am with a funny expression on my face and a broken arm. I was accident prone.

not alone in the world, and suddenly my dream had come true. Finding Daddy was like winning some kind of family lottery. I had a brother now, Richard Jr., and a sister, Elizabeth, who was black and Jewish, just like me. Her mother, Maxine, had never married Richard, and she left him a few months after Elizabeth was born, taking her to Boston, where her Jewish grandparents helped raise her. Elizabeth didn't meet Richard until she was five, when Maxine brought her back to L.A. to make the introductions. Three years later, when Elizabeth was eight, mother and daughter moved back to California permanently, and Elizabeth began to develop a real relationship with Richard.

Back then, I wasn't aware of the similarities, but in later years both Elizabeth and I were struck by the eerie parallels. After all, there aren't many women who can say, "I'm black and Jewish and my daddy is Richard Pryor."

When we first met, I was thrilled that she would even pay attention to me. She was two years older, and everyone at the Pryor compound already knew and loved her, and the fact that she even took an interest in me was nothing short of a miracle. But Elizabeth later told me that she liked me right away, though she admitted that she was a little shocked to meet a four-year-old who swore like a truck driver. *Motherfucker! Pussy! Bitch!* "You sounded just like Daddy," she told me years later. "From that very first day, I felt you were more his daughter than I was."

About a year after that first fateful meeting, Daddy bought a big house on Parthenia Street, in Northridge, about thirty minutes from the old place, and took his entourage with him. I loved that house even more than the one in the hills above Sunset, and for the next eight years, till I was thirteen, it was home to me.

When you arrived at Parthenia Street, you had to wait for the automatic gates to swing open, then you made your way down a long driveway, through a sprawling citrus orchard, till the big, ranch-style house came into view.

It was a low, Spanish-style structure, built around a central courtyard, and you entered the house through a rear door that led to the kitchen—which was the heart of the house, especially when Mamma was around, cooking up her soul food storms.

Dad had two full-time caretakers—Mercedes, the housekeeper, and Raul, the groundskeeper and all-around handyman—and a full-time cook. There was also Rashan, a strong, quiet man who served as both a bodyguard and spiritual adviser. Whenever we kids were there, Rashan would teach us tai chi and try to get us to meditate. We didn't learn much—we were just kids, after all—but we laughed and had fun.

The house had a big dining room, and a living room that was twice the size of the one in the old place. Dad had brought over all of his huge, comfy couches, and all of the groovy African art, and he had an enormous fish tank installed. I could watch those fish for hours.

The bedrooms were in one wing of the house. Dad's room was all dark browns and deep maroons, and it had an enormous bed with black sheets on it. He had a big-screen TV in his room— though not a flat-panel, since those hadn't been invented yet—and sometimes we'd pile onto his bed to watch movies. He had tons of movies—VHS tapes were piled all over the place—and he'd let us hang out till all hours. But sometimes, in the middle of a movie, Dad would stumble into the room, drop onto the bed without worrying about landing on us, and pass out.

I loved his bathroom, too. I had never seen anything so luxurious and opulent, all done up in fancy black marble. There was a shower stall with lots of shower heads, and the biggest Jacuzzi tub I'd ever seen in my life. It looked like Daddy could have held parties in it, and—now that I think of it—he probably did.

Outside, beyond the big yard, beyond the orange and lemon trees, there was a one-bedroom guesthouse that Daddy reserved for Mamma, who often came from Peoria to visit. It wasn't fancy, but it did have its own sauna.

Also, near the guesthouse, Daddy had hired someone to build a little playhouse for us kids. We used to go there to get away from the adults, but sometimes there were spiders in it, so we went very carefully.

Dad's favorite part of the house was the remodeled garage, with its full-size boxing ring. He was a boxing aficionado, and I'm sure that's what first sold him on the house. Whenever there was a fight on cable TV, Dad would throw big parties, and everyone would gather round the TV set and drink and get stoned and holler till they were hoarse. Dad's two favorite fighters were Muhammad Ali and Sugar Ray Leonard.

On those nights that I slept over, which were becoming increasingly frequent, I always stayed in the main house, in the green-tiled guest room, just up the hall from where Mercedes slept. If Elizabeth was around, we shared the room, but when she wasn't there I stayed there by myself. On those nights, I often sneaked down the hall to visit Mercedes and watch Spanish soap operas in her room, on her small TV. I would pretend I understood Spanish, because I wanted Mercedes to like me, and looking back on it I realize that this was simply another way in which I was insecure.

There was also a smallish second floor that Dad had turned into his office. It was lined with plaques and posters highlighting all of Dad's achievements, and it was where he did "business"—whatever the hell that entailed.

He kept his Emmy there, and, in the years ahead, his many other awards, including his Grammys, a couple of things from the Writers Guild of America, and a little plaque from the American Academy of Humor. I don't think I realized that my father was also a writer, but he was. He wrote his own material for his live concerts, of course, and he also wrote for film and television. He got writing credits on a number of hit films, including *Blazing Saddles*, *Car Wash*, *Silver Streak*, and *Blue Collar*.

I don't think Dad liked being alone. There were always people around, and usually lots of them. They would sit there drinking and smoking reefer, and passing the pipe, and whenever Daddy told a joke everyone would laugh—a little too hard, it seemed to me. But he liked it, I guess. He liked sitting there with his friends and with the hangers-on, sipping his Courvoisier from his tall, thin glass, and telling stories. That's what he was all about: stories. The man liked having an audience. He was most alive when he was *on*.

For us kids, however, one of our favorite places was the Olympic-size pool in the back of the property, where we'd play until our finger looked like prunes. Our favorite game was inspired by an episode of *Twilight Zone* we'd seen, in which a husband and wife told their kids that they were getting a divorce, and the kids didn't want to hear it, so they dove to the bottom of the backyard pool and emerged in a beautiful, peaceful world that was far, far away. In that world, families stayed together, and everyone was happy. I guess it doesn't take a psychiatrist to figure out why we were intrigued by that particular game.

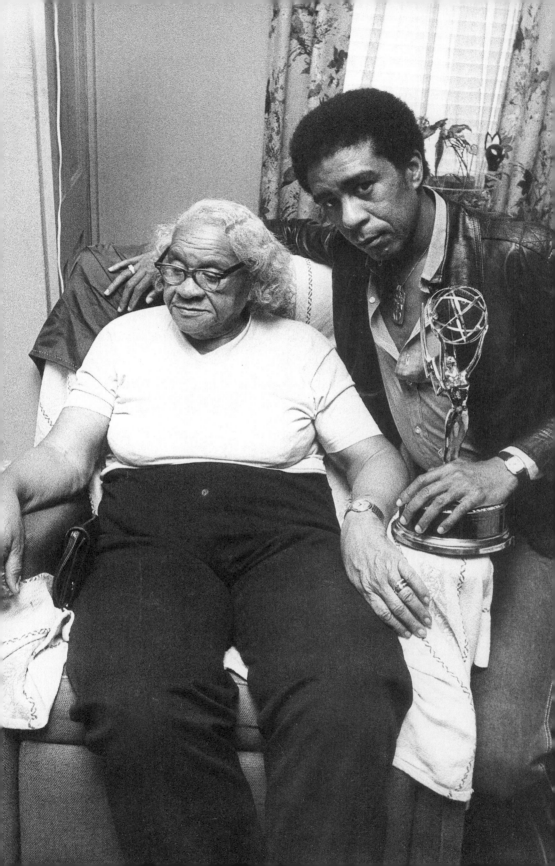

Sometimes, when we were in the pool, we'd cry out to each other: "Auntie Em, Auntie Em!" That was a line from *The Wizard of Oz*, one of my favorite movies, so I guess that we knew Dad's crazy household was as weird and otherworldly as that movie, subconsciously anyway. There's a scene in the movie where Dorothy visits the land of the Munchkins, and the Good Witch Glinda suddenly glides away. "My," Dorothy says, "People come and go so quickly here!" That's what it was like at Dad's place, a constant parade of strangers and lovers and ex-lovers and hangers-on, not to mention all the wannabes—from actors to drug dealers to prostitutes.

Another favorite hangout was the basement, and we found it both fascinating and a little terrifying. It was a finished basement, with a fireplace, a dilapidated pool table, and an old wide-screen television. There were gargoyles on either side of the fireplace, and musty nooks and crannies that almost challenged you to explore them, and I guess that that's what made it scary. We thought the place was haunted, and in fact my least favorite of Daddy's wives, Jennifer Lee, once told me that the whole house was haunted, and that an entire family had been murdered in that very basement. I think she was just trying to frighten us off, because she didn't like having us kids around, probably because we reminded her that Daddy had been with other women (and he may have liked them better than he liked her).

I guess we must have been a little masochistic, though, because we fueled our fear by watching scary movies in the basement. I remember *The Omen* and *The Exorcist* in particular, both of which I

Opposite: Mamma and Dad, holding the Emmy he won in 1973 for Best Writing in Comedy-Variety.

found absolutely terrifying. Daddy knew we were watching horror movies, even though he'd forbidden it, but he got a kick out of watching us run back up into the house, wide-eyed and screaming, so he let us get away with it.

Life on Parthenia Street was very pleasant for those first few years, but before long Daddy began to exhibit some of the erratic behavior that plagued him for most of the rest of his life. I think it must have been the drugs. He would explode for no reason, and he would beat us until his arms were too tired to go on. An hour later— probably once he had his fix—he'd come looking for us again, all sweetness and light. Needless to say, we were forever in a state of imbalance. Dad was many things, and most of all he was completely unpredictable.

When Mamma was around, however, he usually tried to keep himself under control. That was one of the reasons we loved having her come out from Illinois to visit. She ran the house like clockwork, and we got home-cooked meals instead of take-out and frozen pizza. As for Dad's drug use, it continued, of course, and she turned a blind eye to it, and he loved her all the more for it. Other women gave him shit, but Mamma never did.

Mamma would also help him host dinner parties and barbecues, and one time we even had a big roller-skating party that spilled out into the street. One of the guests was Michael Jackson, but I didn't even talk to him.

My father had other celebrity friends, and they were there from time to time. Over the years I met everyone from Bill Cosby to Robin Williams, from Quincy Jones to Diana Ross, from Muhammad Ali to Arsenio Hall, but they didn't seem like celebrities to me. They were just Dad's friends, and I didn't know any-

thing about them or what they did, and they didn't strike me as any different from any of his other friends.

Mom had a few celebrity friends of her own, like Melvin van Peebles, who'd been hanging with her and Daddy forever, and Lily Tomlin, with whom we celebrated Christmas one year. I knew Melvin van Peebles made movies, and maybe wrote, too, like Daddy, and I knew that Lily Tomlin was funny, also like Daddy, and that was good enough for me.

At one point, when I was about eight or nine, Mom began leaving me at Dad's house more and more frequently. She said she wanted me to bond with him, and maybe she meant it, but I think she was going through another one of those periods where she was trying to make sense of her life. Nothing seemed to be working out for her, though. She had started out with such promise, and she still had absolutely nothing to show for it.

By this time I really liked hanging out at the Parthenia house. Dad wasn't much good at fatherhood, and he knew it, but he made up for it by entertaining us in other ways. He was always buying us pets, for example. I had a land tortoise, Myrtle, that lived on the property for years and years, and for a while we had a miniature pony, named Ginger—until the dogs tore her apart (literally). We even had a couple of monkeys, briefly, but they tried to fuck anything that moved, including visitors, and one day they were simply gone.

"Where'd the monkeys go?" I said.

"Monkeys?" my dad said. "What monkeys?"

"The two monkeys we had!"

"Ain't no monkeys here but you kids!"

He was only fooling, of course.

The only time I was unhappy at his house was when he wasn't

there and I was left alone with the staff. It's not that I didn't like
them, but it didn't make any sense. He would go off for a week
or two, and I'd have no one to play with, so it was a real drag. I
could talk to Mercedes, of course, and in the morning I could chat
with the chauffeur who drove me to school, but it wasn't the same.
I never did understand why my mother just left me there. I imag-
ine she was dating at the time, and hoping for a fresh start, but I
was a big girl by then, and if she had asked nicely I would have
known how to make myself scarce.

When Daddy got home, and I complained, he told me to stop
whining. "My house is a much more stable environment that your
mother's house," he said. We were interrupted by the arrival of a
hooker. "Hey, baby, come on in," he told her, salivating a little. "You
look hot!" Then he turned back to me: "Your mother's always going
through crazy shit, so this is the right place for you."

Then he looked at the hooker again and his eyes got wide and
happy. It was time for pussy, and pussy was Dad's favorite thing in
the whole wide world.

There were so many hookers coming in and out of the house
that I accepted it as a fact of life, as my father had done in his own
youth, and their comings and goings resulted in an incident some
years earlier that became part of the Pryor family lore. It was
Thanksgiving. Dad had a lot of friends and family there, including
Mamma. He also had a couple of girls stashed in the bedroom,
who were still recuperating, and it seemed like they were taking
their sweet-ass time about going home.

Finally, Mamma called everyone to the table. I remember walk-
ing past Dad's bedroom, and hearing the girls saying they were
waiting on their money, so when I got to the table I sat down and

immediately turned to look at him. "Daddy," I said. "The whores need to be paid."

For a moment, everyone looked at me in stunned silence, then they all burst out laughing. I didn't know what they were laughing about. And, truth be told, I didn't know what a whore was. But I knew whores had something to do with fucking, and fucking was fun, as my Daddy had assured me, so whores were a good thing. And they had to be paid! Just like the chauffeur and the groundskeeper and the man who took care of the pool. Hell, I'd seen Daddy pay them, and he always paid with *wads* of cash.

When the laughter died down, Daddy went off to pay the whores, and then we had ourselves a wonderful Thanksgiving dinner.

Whores were part of our lives, I guess, and they'd always been part of Richard and Mamma's lives, going back to the old days in Peoria. Daddy had lived in a whorehouse then, and in some ways he was still living in a whorehouse. Or, to look at it another way, he'd been carrying that whorehouse on his back his whole life— brought it with him all the way from Peoria.

Years later, I would think back on all of the shit I endured at my father's hands—the abuse, the endless stream of whores, the hostile ex-wives and even more hostile girlfriends, the loneliness, the exposure to drugs—and I wondered why I wasn't angrier with him. But I never felt anger. The motherfucker had a hold on me, and I couldn't help but love him.

Also, when you put it into perspective, I learned a lot about parenting from him. If I'm ever lucky enough to have kids, I'll do exactly the opposite of what my dad did to me, and I know they'll turn out fine.

5.

_____

# THE GOD OF COMEDY

During those early years, I bounced between three different households—Mom's apartment, Dad's place, and Bunny and Herb's apartment in Marina del Rey—and all three were a little crazy. My father was a famous entertainer, my grandfather represented entertainers, and my mother wanted to *be* an entertainer. So I guess it should come as no surprise that I wanted to be an entertainer, too. And, as everyone knows, most entertainers are nuts.

When I was only nine years old, my mother introduced me to the circus, and, more specifically, to the world of clowns. Years earlier, in New York, she had become a self-taught photographer, and she got a job taking pictures of the clowns at the Ringling Bros. and Barnum & Bailey Circus. She did such a good job that her friends would call whenever the circus came to town, and we'd go off to see them.

I don't know what it was about clowns, but they absolutely fascinated me. I loved the fact that a normal person could paint his

face, put on a big red nose, slip into a pair of large, floppy shoes, and become a completely new person. I know it's similar for actors, but it's not exactly the same: when a person becomes a clown, the transformation is complete. And the notion that one could become a wholly different person, that really appealed to me. (Gee, I wonder why?)

Whenever the circus was in town, I always rode in the parade, and whenever the clowns walked into the audience, to invite someone into the ring, they invariably found me. The first time it happened, I felt like the luckiest little girl in the world, and as it

My mom and I almost ran off and joined the circus. Here she is in the early 1980s.

continued to happen—I got picked every year, year after year—I finally figured out that Mom was behind it. These were her friends, after all, maybe her only friends, and they would do anything for her.

One of the clowns, Skeeter, a black man, became my mother's boyfriend for a time, and he was endlessly entertaining. We played cards together, spent hours hovering over board games, and even practiced magic tricks. He also bought me a parakeet named Twinkles that I was absolutely crazy about.

Once, at school, I drew a picture of Skeeter in an art class, and I was reprimanded by the teacher. "Now, Rain, you know there's no such thing as a black clown," she said.

"Yes there is," I insisted. "There's Skeeter. And sometimes he lives with us."

My teacher didn't believe me, and I couldn't convince her otherwise. I went home, wanting to ask Skeeter if he could come to school with me the next day, and talk to the teacher, but he was gone by then, off to entertain audiences in other cities.

My fascination with circuses continued into my preteen years, and on one occasion, we went to see Circus Vargas, one of the more modern, European-style troupes. My mother brought her camera, befriended the clowns, and had such a good time with them that she decided to launch a new career. For the next two weeks, she worked with the clowns of Circus Vargas, developing a character of her own—a whimsical, childlike figure called Papillon—and entertaining audiences. I went to most of her performances, and I was enthralled by the transformation. My mother was gone, and Papillon had taken her place. I definitely liked Papillon better.

Often, her fellow clowns took me aside and taught me a few

things about the profession. I learned a few funny magic tricks, some basic acrobatics, and how to juggle.

"You know what?" my mother said one night, unable to contain her excitement.

"What?"

"We're going to join the circus."

"What do you mean?"

"You and I," she said. "We're going to run away and be clowns together!"

I thought it was a great idea, and Mom began looking into the possibilities. She made some calls to inquire about tutors, so that I wouldn't fall behind in school, and we even ran around looking at used trailers which might serve as our future home.

"This is going to be the adventure of a lifetime!" she assured me. "We'll be together all the time. We'll be happy and things are going to work out and I'll become the mother you deserve."

I was thrilled. I was too young to understand the depth of her pain. I was too young to see how badly she was hurting inside.

"A fucking circus!" Dad bellowed when he was told about the plan. "No daughter of mine is goin' on the road with no mother-fucking circus!"

That was the end of that dream, and for a while I was completely crushed, convinced I would never recuperate.

Dad—being Dad—made up for it in other ways, of course. The next thing I knew I was being whisked off to all sorts of exotic locations, along with Elizabeth and Richard Jr. We were his three eldest kids, and we certainly got the best deals.

His favorite places were London, Paris, Hawaii, and Jamaica, and I went to all of them.

When we went to Paris, we flew on the Concorde and hopped into a waiting limo for the ride to the swanky George V Hotel. It was the most elegant place I had ever seen in my life. The doorman wore white gloves and bowed as we came through.

The thing I remember best about Paris were the dogs, which were absolutely everywhere, even in all the finest restaurants. Lots of restaurants had little mats under the tables, where the dogs could nap as the owners dined. The other thing I remember is hearing little kids talk French. I thought it was the most amazing thing in the world. I remember pointing this out to Elizabeth, telling her, "Isn't that incredible? Little kids, five and six years old, and they speak fluent French!"

"Rainy," she said, "they speak French because they're French. And French is all they speak."

Well, duh.

One year we went to Paris with what seemed like *all* the siblings, and Daddy took us to see *Silver Streak*, a movie he'd done with Gene Wilder and Jill Clayburgh. The movie was dubbed and my on-screen Daddy was speaking French, which I found hilarious.

After the movie, on our way back to the hotel, Daddy had the same question for each one of us.

"Elizabeth, who is your favorite comedian?"

"You, Daddy! You!"

"Junior, who is your favorite comedian?"

"You, Dad! You!"

"Renee, who's yours?"

"You, Daddy," she said, but she said it without much enthusiasm.

Then it was my turn. "Rain, who is your favorite comedian?"

"Steve Martin, Daddy! Steve Martin!"

He was laughing, but I could tell he was a little pissed off. "Well, let's see if Steve Martin gets you any Christmas presents this year," then he looked away and mumbled: "Fuck Steve Martin."

I liked London, too, especially the accents, and I remember watching the changing of the guard at Buckingham Palace, and going to the Tower of London, where they used to torture people. Apparently, the British were very big on torture—it seemed almost like a national pastime. I went to Madame Tussaud's, too, and at first I couldn't believe that the wax figures were made of wax. I was sure they were real people, standing very, very still, and that at any

Dad with Gene Wilder in *Silver Streak*

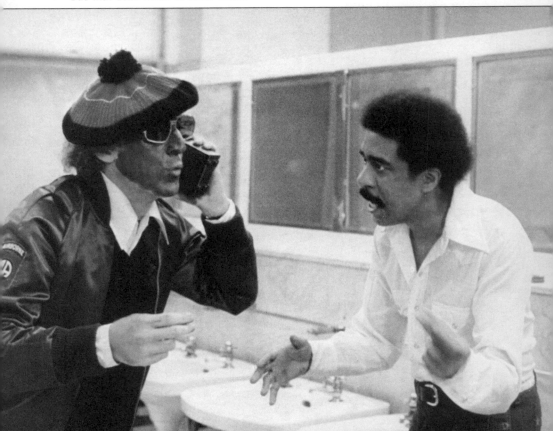

moment they were going to leap out and scare the bejesus out of me. I wasn't a fan of being frightened. I remembered Daddy's basement, and the day I watched Linda Blair in *The Exorcist*, hurling pea soup clear across the room, her head spinning completely around.

I was also kind of impressed with the notion of celebrity. When we were back in Los Angeles, we didn't go out much. We mostly stayed home, and people came by the house, and my dad was just a regular guy. But here in Europe, people recognized him wherever we went, and they asked for autographs, and he was always very polite and accommodating. The only time it bothered him was if we were in the middle of dinner. He hated it when people interrupted our family meals, but he was nice about that, too. "Let me finish having dinner with my family," he'd say, "and if you're still here when we leave, I'll be happy to have my picture taken with you."

I've got to admit, I liked the attention. I felt a bit like a celebrity myself, especially when we were riding around in limos. There's just something about limos that makes this girl go weak at the knees! And I liked the *power* of celebrity. I knew my father wasn't God, of course, but sometimes people treated him as if he were—the God of Comedy?—and it didn't seem like such a bad thing at all.

As the years passed, Daddy seemed to find us kids increasingly entertaining. We were kids, but we weren't babies, and he seemed to enjoy watching us evolve. When he was funny, we got it, and we laughed, and I think that meant the world to him.

I remember going fishing with him once or twice, and feeling like a regular family. Daddy would teach us all about bobbers, show us how to fasten a lure or bait a hook, how to cast, and how to

snag those babies when they bit. We used to catch small trout and even smaller porgies, and Dad would get so excited every time we caught something that he'd clown and jump around and act like we'd snagged a *motherfuckin' shark*.

Sometimes we'd take the fish home and he'd gut them and clean them, showing us how it was done, and then he'd throw them on the grill with a little olive oil, and lemon from our own lemon trees, and we'd enjoy the fruits of our labor. I always loved those times because it was as domestic as he ever got, and he seemed just like a regular father.

But he wasn't a regular father. He was an artist, and he was hugely successful, and most of the time he was consumed by his up-and-down career.

In 1977, for example, when I was eight years old, he had a series on NBC—*The Richard Pryor Show*—and right from the start it seemed to be in trouble. I was too young to know what was going on, but from what I heard he was a little too "out there" for the censors. It really pissed him off. One night, back at the house, he was addressing his entourage, and he was fuming. "This nigger's not going to let anyone tell him what he can and can't say," he said. "I'm not changing a motherfucking word for those people."

He didn't change a word, and the show was canceled after only five episodes.

Dad was living with Deborah McGuire at the time, whom I'd seen around, and in September of that year he went off and married her without telling anyone. I liked Deborah. She was slim and black and wore her hair pulled back in a tight bun, and she always

Opposite: My father's NBC show was short-lived.

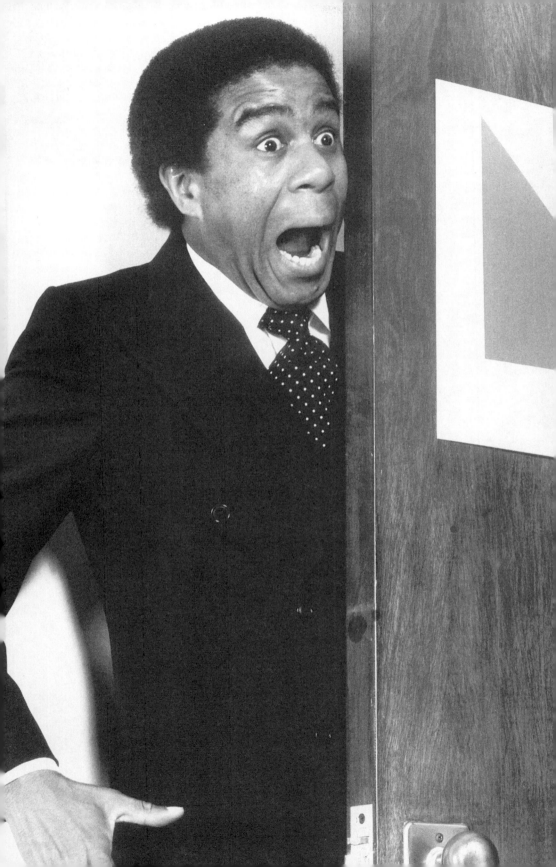

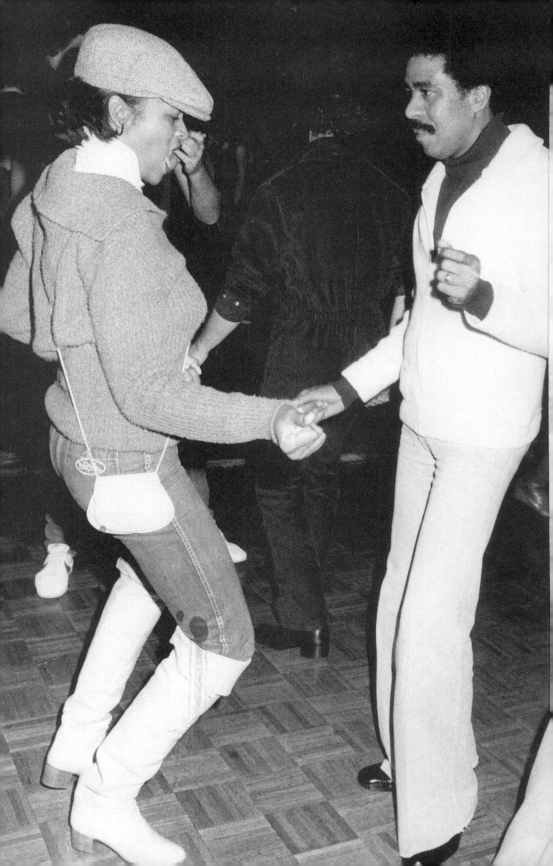

looked elegant as hell. I also liked her because she never took any shit from my father. One night, though, probably still reeling from the losing battles with the NBC censors, Daddy walked out into the driveway with his .357 Magnum and filled Deborah's car full of holes. That was the beginning of the end. Deborah was a tough broad, and Dad had never once raised his hand to her, but his bull-shit was getting way beyond acceptable.

There was another woman on the periphery back then, Jennifer Lee, who was actually one of Dad's employees and who took care of a lot of his day-to-day business. She was very attractive, and she seemed to have her eye on Dad. For some reason I couldn't understand why I didn't like her at all. I don't know what it was—call it Rainy's intuition—but I knew she was trouble.

Jennifer also happened to be white, and by this point, I was at an age where I was becoming more acutely aware of race.

At the time, I was in the fourth grade, and one morning a skinny red-headed kid with freckles pushed me to the ground and called me a "nigger." I had heard my father use the word, and I had heard plenty of other people use the word, but never with that nasty edge. So I went over and called the kid a "motherfucker," like I'd heard my parents call each other, and buried my teeth in his arm.

I got called into the principal's office—and, mind you, the principal was black—and I was severely reprimanded. After school I told my mother all about it and she went absolutely ballistic.

The next morning, she accompanied me to school and marched me into the principal's office. "You've got some nerve!" she hollered.

Opposite: Dad with Deborah McGuire, the one wife who took no crap from him.

"You've got a little white, red-headed motherfucker calling my girl a 'nigger,' and she bites him, and *she's* the one who gets into trouble! Something's wrong with this picture!"

"Ma'am, I'm going to ask you to watch your language."

"Watch my language! You ain't gonna ask me shit, mother-fucker! You going to find that little honky kid and have him apologize to my daughter."

I never got the apology, but the honky kid heard about my mother's visit, and he heard she had scared the principal, and he steered clear of me forever after.

Man, Mom was *pissed*—and I loved her for it. Someone had called her baby a "nigger," and she was indignant, and she had come to my defense. That's what mothers were supposed to do. They were supposed to protect you. And she'd done it.

It helped, of course, but it didn't change my world. For years to come, the black kids would tell me I wasn't black enough, the Jewish kids would tell me I couldn't possibly be Jewish, and even some of the teachers got into the act, albeit not always deliberately.

"How come I'm the Gingerbread Girl? I want to be Raggedy Ann."

"Rain. Look at your skin. It's *brown*."

*Man, why don't you come out and say it? Say the fucking word already!*

I was used to hearing it, of course, but in Daddy's house the word "nigger" was always an expression of love. It was never "nigger," though: it was "nigga." *Nigga, get this nigga a drink! Nigga, get your black ass to bed. Nigga, put that pipe down before yo' mothafuckin head explodes!*

Interestingly enough, after that incident at school, my mother

asked Mamma if she would please talk to me about race. I was a biracial child, but people thought I was black, and they identified me as such, and my mother thought I should get a handle on my ethnic identity.

I remember Mamma taking me aside one day, with her tarot cards, and she began by talking to me about the cards, teaching me what each card meant, and how the position of the cards always affected one's interpretation. Then she paused to shuffle them, and she began to talk about the subject that was really on her mind.

"If you black, you is a nigga in my house," she said. "And you black, Rainy. The world's gonna see Rain as a nigga no matter what her mother is. So nigga it is. But remember this: in my house, nigga is a term of endearment. People say, *Nigga, please!* Or, *Nigga where you been at?* Or, *Don't fuck wit me nigga cause I'll stick my foot up yo' ass!* But it don't mean shit. The word nigga only mean shit if you make it shit, and people who make that word shit—well, those people ain't welcome here."

"What about 'honky'?" I said. "Can that be shit if you make it shit?"

"*Honky!* Hell no! That word don't have the same punch now, do it? Honky never hurt a white man's feelings, no matter how harsh you deliver it. It ain't got no edge. But the word nigga—that word's got power. Wrong man uses that word, it'll put sweat on your palms and make your heart race."

"So that boy who called me nigga, he was wrong?"

"He sure enough was!" she said, her voice rising. "He don't have a right to call you nigga. If you want my opinion, I don't think any white man has the right to call a black man nigga. That word don't belong to them. It's our word, and only we know how to use it right.

When a white man uses that word, nine times out of ten he means it hard."

After Mamma went back to Illinois, my own mother took off on an extended trip, to places unknown, and I stayed at my daddy's for several weeks. He was in a lousy mood, and it seemed like every day he'd scream at me and beat me for no reason.

Many years later, when I was an adult, I tried to make sense of his erratic behavior in a letter to Elizabeth. I wrote her as follows:

*For me there is nothing normal about how I grew up and how we grew up with him. I have forgiven Daddy for being a shitty dad because he really could not have changed. I believe Daddy was also mentally ill, that he was bipolar and never took medication for it. I believe that's why his actions had no rationale, why his anger was so quick. Yeah, I know the cocaine and the alcohol didn't help, it just made it worse. Do you know he made me get his cocaine for him one time and cut it up? Then one day he blamed me for his addiction and I swear I felt like killing myself.*

It sounds like I was exaggerating, but I wasn't.

When my mother came back from her mystery trip, she was in a foul mood, too, so the moon must have been in the wrong motherfucking house. Day after day, she would rage about the fact that nothing ever went right for her, and that she could never catch a goddamn break. "It's your motherfucking father!" she bellowed. "He never raised a hand to help us. I have to do everything for you!"

This hurt, of course, but I tried to suck it up. I didn't realize it then, of course, but my mother was bouncing between extreme rage and extreme depression. "That son of a bitch gets rich and I've got to beg for every little morsel!" she shouted. "How am I going to manage with you underfoot all the time?"

Okay. That was it. My mother was struggling to succeed, and the only thing standing in her way was me, her daughter. The solution was self-evident. I would kill myself! She would mourn for a month or two, then she'd get over it, quickly, and go on to become a huge success.

But how to kill myself?

Then I remembered watching a TV movie where someone slapped a plastic bag over another person's head and held it there until they died. Suffocation! Perfect. Who says TV isn't educational?

You hate me! I know you hate me! I asked my mother, hoping that I didn't have to go through with the plan.

She just looked at me, shaking her head, and said nothing.

That was all the confirmation I needed. I went into the kitchen, found a plastic bag, and put it over my head.

About ten seconds into it, while I was still breathing without difficulty, my mother walked into the kitchen.

"What do you think you're doing?"

I was going to answer, but I had a bag over my head, and I didn't think a girl trying to kill herself should try to make casual conversation.

"So you're trying to kill yourself, huh? Good. Let me call the suicide hot line."

I just shrugged, still not speaking.

"Rain, did you hear me? Take that fucking plastic bag off your head! If you don't take it off at the count of three, I'm going to call the suicide hot line. One. Two. Three. Okay, that's it!"

As I watched, still breathing regularly—I began to suspect that the bag was full of holes—she picked up the phone, found the

number, and dialed. While she waited for them to pick up, she turned to look at me, seething. "I know what this is, Rain. This is a ploy for attention. Well, you think it's going to bring your father here, you're wrong. When are you going to get it through your head? He doesn't care. *He doesn't care.*"

As you might imagine, that made me feel absolutely wonderful.

Someone picked up at the other end. "Hello, suicide hot line? Can you help me? It's my daughter. She's put a plastic bag over her head and she's trying to kill herself, and she's driving me fucking crazy."

I took a moment to remove the bag from my head so I could scream at her: "You're *already* crazy!"

"Hello?" She looked at the phone in her hand. "What the fuck? Are you kidding me?!" She turned to look at me again, angrier than ever. "They put me on hold! Can you believe this shit! The fucking suicide hot line put me on hold! Rain, take that fucking plastic bag off your head!"

I took the plastic bag off my head, since clearly it wasn't working, and I screamed at her. "I hate you! I wish you had listened to your parents and given me up for adoption. You ruined my life!"

"Oh yeah? I haven't even *begun* to ruin your life!"

I ran out of the kitchen, sobbing, and locked myself in my room, and she didn't even bother to look in on me. Maybe it was true that my father didn't care, but at that moment I felt she cared even less than he did. At that moment, I genuinely hated her.

Not long after, I came home from a weekend on Parthenia to find her asleep on the couch. I was worried about her, and I shook her until she woke. "Mom? Mom, are you okay?"

She looked at me, slowly regaining consciousness, and she

didn't exactly seem happy to see me. "So you're back from your beloved Daddy's place," she said. There was an edge in her voice. "How wonderful! I suppose you expect me to entertain you now."

"No," I said. "I was just worried about you. You don't look so hot."

"Well, you don't look so hot, either!"

"That's not what I meant, Mom!"

She proceeded to rail against me for all the trouble I had caused her, and I stood my ground, determined not to cry. I didn't have any idea what I'd done, but either I was crazy or she was crazy, and I hoped it was her. I remember thinking, *She is fucking crazy. She's as crazy as my dad. How did I score two totally crazy parents?*

"Why don't you just leave me?" she said once. "Why don't you just move in with your motherfucking father? If you love him so much, why don't you just forget about me and move in with the bastard?"

"I love you, too, Mom."

She shot me a dirty look.

"It's true, Mom. I love you."

And it *was* true. I loved them both. For almost ten years, they'd managed to completely mess up my childhood, and I still loved them. It made no sense. Then again, maybe that's why I loved them.

# 6.

# MAN ON FIRE

Early in 1979, when I was ten years old, I saw my father perform for the first time. He was in Long Beach, California, and I was watching from behind a curtain, off to one side of the stage. Until that moment, I never really understood what my father did for a living, and I can't say I understood everything he was saying, but I certainly saw his *power*. Yes, that night, watching Richard Pryor strut across the stage, watching him take command of that theater, I finally got it: my daddy didn't just tell jokes. He told funny stories that dug for deeper truths.

For years, I'd been asking my father to "teach" me some jokes. He was a funny man, and I wanted to be funny, too. But he never taught me any jokes, because it wasn't about the jokes, and that night in Long Beach I finally began to understand it. Comedy was about connecting with people in places so personal that it actually made them uncomfortable, and then showing the humor in it.

Hell, comedy was *hard*.

Mamma came to visit not long after. She was tired all the time, slower, shuffling from couch to chair and back again, always looking for a place to park her tired body, and it struck me that she was getting on in years. Daddy noticed it, too, I guess, and he wanted to do something nice for her, and for the family, so he took a bunch of us to Jamaica. Elizabeth came along, as did Deborah, who by this time had forgiven him for emptying his .357 into her car.

We took separate flights, though. Daddy had developed this crazy but short-lived notion that he was going to die in a plane crash,

*Richard Pryor: Live in Concert* (1979)

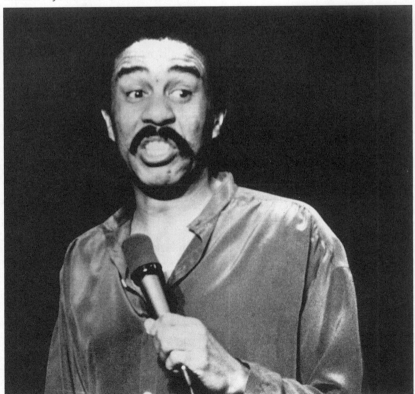

and he didn't want us to die with him, so he got a little neurotic about travel. It was still special, though. The limos. The VIP lounges. The airline employees who escorted us onto the plane as if we were royalty. Man, I miss those days!

We stayed near Kingston, in a big, beautiful airy house with a female chef and female housekeeper, and from the moment we arrived I fell in love with the island. I loved the British accents, which reminded me of Mary Poppins, and I loved the pristine beaches.

On the second day, we were taken on a tour of the old plantation house at Rose Hill, and we heard horror stories about slavery, which made a very deep impression on me.

But by the third day the only thing making an impression on me was my father's foul mood. It's as if a black cloud had settled over him all of a sudden, and no one could figure out what it was. (Withdrawal, maybe?) He kept picking fights with Deborah, calling her nasty names—he never hit her though, because this woman knew where to draw the line—and he wandered through the house at all hours, mumbling and cursing at unseen ghosts.

The next night, we were gathered at the dinner table, which was always impeccably set, and Daddy was in such a foul temper that the whole house was tense. One of the young servants emerged from the kitchen and went around the table, setting a hot dinner roll next to each of our plates. When she reached me, I said, "Thank you, Doda," and a split-second later I felt the back of Daddy's hand smash into my face. I put my hand to my face and felt blood pouring from my nose, and I immediately burst into tears.

"What did I tell you about disrespecting people?!" Dad bellowed.

"But she asked me to call her 'Doda,'" I protested, blubbering. "She *asked* me!"

Doda herself came to my defense, her head bowed, too afraid to look Daddy in the eye. "It's true, sir. It's my nickname. All my friends call me Doda."

"What the fuck is wrong with you people?!" Dad shouted, looking at us as if we were the enemy.

"I didn't do anything wrong, Daddy!" I repeated, still wailing.

"Don't you talk back to me, goddamn it! I'm sick of your lip!"

Mamma jumped to my defense. "Now goddamn it, boy—leave the girl alone! You about broke her nose! Junior, help your sister get cleaned up. We can't have her bleedin' all over the table."

My brother led me out of the dining room, and as we moved off we could hear Daddy getting increasingly worked up. *Everybody was out to get him. They were playing him for a fool. Couldn't even trust his own motherfuckin' family.*

He was rambling, paranoid, and he left the dinner table in a huff, cursing everyone in the room, except Mamma, of course. In the morning, the entire incident was forgotten, and we spent our last few days in Jamaica like a normal, happy, well-adjusted family. Hell, we'd practically turned *white*.

Shortly after we got back, though, Deborah disappeared from our lives. This struck me as odd, because we all liked her, but by this time he seemed to have developed an active interest in Jennifer Lee. From the moment Deborah left, Jennifer was more girlfriend than employee, and I can tell you I wasn't very happy about it. I didn't like Jennifer, and she liked me even less.

Daddy must have really loved her, though, because he would beat

the shit out of her, and she must have really loved him—because she always took it.

That same year, 1979, Mamma died. Daddy was beside himself. His own mother had died years earlier, and I'm sure it affected him, but his real bond was with Mamma. She was his rock, the one person in his life he trusted beyond all others, and now she was gone.

He took Elizabeth and me back to Peoria for the funeral. Jennifer didn't go. I imagine she was invited, but a few days earlier he had beat her again, and she had decided to move out.

The funeral was a very sad affair. Mostly I remember Daddy sitting in the front pew, next to me, his head bowed, tears streaming down his face and spilling onto his shiny new pants. The reverend was delivering a long eulogy, about what a fine woman Mamma had been, a real pillar of the community, and I guess that must have made the whores feel pretty good.

When it was over, Daddy went back to the coffin to say goodbye to Mamma one last time, and he collapsed. He had to be carried out, which was scary for us little girls, and it took him awhile to recover. Now that I think of it, though, I'm not sure he *ever* recovered.

The following day, we flew back to Los Angeles. Daddy was a broken man, and he must have felt he had nothing to look forward to. "I can't go on," he told us, which was probably the wrong thing to do, since we were both young girls, but I guess he needed to tell someone, and we were handy. "I just don't see how I can go on. Nothing means shit no more."

He recovered, more or less, and that Christmas we went to

Hawaii for the very first time. We flew to Honolulu, first class, as always, and then we took a private jet to Maui. Dad was apparently over his paranoia about dying in a plane crash, and sat in the copilot's seat and asked the pilot a lot of questions. That was one way to get over his fear.

We stayed in a luxurious house that was part of the Hotel Hana Maui, one of the nicest resorts on the island, and the only glitch was Jennifer: she'd come crawling back, and Daddy had invited her along.

Despite her presence, the trip got off to a very nice start. Daddy took us fishing, he spent a lot of time at the beach with us, and he was in fine spirits. I think he was working really hard at getting over Mamma's passing.

One time he swam out really far, and we kept shouting at him to come back, because he was making us nervous, but he kept waving and going farther out, until he was no more than a tiny black dot with a wet Afro. When he finally got back to shore, he collapsed on the beach, exhausted, and lay there for a while, trying to

We loved to spend time together in Hawaii. Hana Maui was the one place where Dad could be himself and we could be his kids.

catch his breath. "What is wrong with you motherfuckers!" he said, half laughing. "Couldn't you see I was drowning out there! Couldn't you hear me calling for help!"

The people on the island loved Daddy, and he showed his love for them by writing a big check to help one of the local schools, then topped it off by buying Christmas presents for all of the kids.

Even Jennifer was in a good mood that Christmas, and my feelings for her began to change.

What I didn't realize then—what no one realized, I guess—is that Daddy was in a deep depression, sparked, no doubt, by the death of his beloved Mamma.

The depression worsened, and on June 1, 1980, all hell broke loose. As you've probably guessed, I'm talking about the freebasing accident, which turned out not to be such an accident after all.

The first news reports noted that my father had been smoking crack cocaine, and that he accidentally set himself on fire. But the truth turned out to be much simpler. He was in some kind of psychotic state, induced by a combination of depression and drugs, and the man poured a bottle of rum over himself and struck a match.

The great irony is that my father was at the peak of his fame at the time. He was very proud of the fact that a man with no education, raised in a whorehouse, had become the best known comic in America, and that—as the newspapers never tired of pointing out—he was the highest paid black entertainer in America.

Despite his success, though, Richard Franklin Lennox Thomas Pryor felt like killing himself. His Mamma had just died. She was eighty-nine, so you'd think he would have been prepared for it, but he simply couldn't get over her passing. He felt ambushed by grief,

lost, unmoored, heartbroken, devastated. Mamma had been the dominant force in his life, and his only close relationship since her passing seemed to be with cocaine. Even Jennifer Lee was no longer at his side. She had been beaten so often, and so ferociously, that shortly after we returned from Hawaii she left and swore never to return.

The day of Daddy's so-called accident was easy enough to piece together. He had been partying that day, as usual, with friends, including his old football buddy and fellow actor, Jim Brown. For a while, everything was going smoothly. The men were swapping stories, telling tall tales, and sharing laughs. At one point, though, Daddy started sinking into one of his depressive rages—rages that were fueled by drug use, and which were becoming increasingly frequent—and he retired from the party.

A short while later, Jim went looking for him and found the door to his bedroom locked. He knocked a few times, but Daddy didn't answer, and Jim figured he had passed out for the night, which wasn't all that unusual for him.

But the fact is—as I learned later, from my father himself— Daddy was falling apart. He was in his room at the time, behind locked doors, pacing, much as he did on stage, taking hits from the bottle of rum in his left hand, and talking to Mamma. Yeah, that's right. He'd been talking to Mamma since she'd passed away, and the conversations were getting more and more frequent.

"I'm going to kill myself, Mamma."

"Why you going to do that, baby?"

"I'm not happy."

"Where is it written that a man's got to be happy?"

"I'm fucking everything up, Mamma!"

"Well, that's a start, boy—at least you know it's you that's doin' it!"

"I'm trying to change things, Mamma. But I can't. I just want it to end!"

"How can you change things if you dead, baby! It ain't yo' time to go?"

"How do you know that?"

"God decides when it's your time, boy, not you. You hearin' me? Richard? You listenin' to me?"

He was listening, or half listening, anyway, but there was someone else in the room with them, and that was Mudbone. Mudbone wasn't real. Mudbone was an old wino from Tupelo, Mississippi, created by Daddy for his comic routines, and by this time Mudbone was already a big hit with audiences. He was a storyteller, not a jokester. He was a philosopher who tried—with very limited success—to make sense of life's many mysteries.

And at that moment Mudbone was telling Daddy to end it. The son of a bitch had turned on him. *Life made no sense*, he said that night in Daddy's bedroom. *Man spends his whole life trying to make sense of things, and in the end it don't mean shit. Gonna die, anyway. Why prolong the misery?*

"Richard?" Mamma said. "Are you listening to me, boy? Put that bottle down and pull yourself together."

But Daddy wasn't listening anymore. He was confused. There were too many voices in his head, too much goddamn noise. He looked at the bottle in his hand—it was still half full—and poured what remained over his head. It dripped through his Afro, over his

almond-shaped eyes, past his lips, and onto his fine-ass silk shirt. Then he reached for his bong and a rock of cocaine, set the rock in the bowl, and fished his lighter out of his pocket.

It was no accident, people.

My daddy knew exactly what he was doing.

He flicked the lighter, and—*poof!*—he burst into flames.

Engulfed, he ran from the room, screaming. Ran through the house, still screaming, and ran down the street, still screaming.

The police found him more than a mile from the house, mute with shock, not screaming anymore, the upper half of his body covered in festering burns.

I was with my grandparents that night, in Marina del Rey, oblivious, but word of the incident quickly spread. And of course everyone in his family was notified—ex-wives, ex-girlfriends, current girlfriends, kids, aunts, uncles.

As soon as my mother heard, she raced to the hospital to donate blood, and she sat by his bed till morning, refusing to leave until the doctors assured her that he was going to pull through.

By the time she reached the parking lot, the press was already there, and one of the photographers recognized her. "Hey, Shelley, bring a camera next time," he said. "A picture of your ex in a hospital bed would fetch serious money."

"Fuck off," Mom said, and she climbed into her car and sped away.

I didn't know anything about anything, but I eventually found out—when Dad came clean—that the press got it all wrong. He had tried to commit suicide, he told me. The notion that it had been

Opposite: Dad, not long after his "revolutionary suicide attempt"

an accident had been created by his management team to protect him from the media.

It's still hard to get my mind around it. The management team had two choices. One, *Mr. Pryor tried to kill himself.* Two, *Mr. Pryor set himself on fire by accident during a psychotic episode that got out of control after he ingested massive amounts of cocaine and booze.*

Which would you choose?

I still knew none of this, of course. All of this came later. At the time, I was at my grandparents' place, getting ready for bed. And in the morning, while my father was in intensive care, still fighting for his life, I was busy getting ready for school. I had breakfast, Grandpa Herb lit his first cigar of the day, and then he and Bunny and I went downstairs and got in his car.

My grandparents bickered all the way to school, as usual, drowning out the radio, but then the newscaster interrupted the broadcast with an update on Richard Pryor's condition, and his tone caught our attention. Mr. Pryor remained in the hospital, still in critical condition, but he was expected to survive. He had suffered third-degree burns, mostly to the upper part of his body, and a team of doctors was tending to him.

For a moment, I couldn't speak, then the words finally came. "Daddy!" I yelled. "My daddy's in the hospital. My daddy's hurt. I want to see my daddy."

I guess Herb and Bunny were in shock themselves. Richard's marriage to their daughter hadn't worked out, but they still had feelings for the man.

"Now, honey," Bunny said, faltering, and turning in her seat to face me. "There's nothing we can do for him now. He's in the hos-

pital, just like the reporter said, and it sounds like he's getting the best possible care."

"I want to see him!"

"No. That's not going to happen. You need to go to school, and we'll deal with all of this at the end of the day."

When I think back on that morning, it's hard for me to believe that my grandparents handled it the way they did. I'm sure they thought they were doing the right thing by having me stick to my routine, knowing full well that I would not even have been able to see my father that day. But I was a ten-year-old girl, and I was scared. I needed to be comforted and held. I needed to be told that every-thing was going to be all right, even if it wasn't true. Instead, they dropped me off at school and forced me to deal with it on my own.

"Chin up, honey," Grandma said. "We'll see you at the end of the day."

"You hang in there, Rainy," Grandpa echoed. "Just get through the day and everything's going to fine."

They pulled up in front of my grade school, the Beverly Hills Vista. Bunny got out and opened my door and managed a smile. I didn't even hear what she said. A moment later, they were gone. I found myself standing on the sidewalk, alone, clutching my school-books and my lunchbox and feeling more isolated and abandoned than I'd felt in my entire life.

*Hello! Is anybody out there? Does anybody care? Do I even exist?*

I watched their car pull away, hoping they would change their minds and turn back, but they kept going and disappeared from sight. I turned and made my way past the manicured lawn, toward the Gothic-style brick building that housed the school, fighting

tears. I didn't have any idea how I was going to make it through the day.

"Your dad is a burnt piece of shit!"

I turned around. It was a kid from my class. A kid I hardly knew. I dropped my books and my lunchbox and jumped the son of a bitch, fists and feet flying. I beat the crap out of the kid and felt *good* about it, and a moment later—almost like a time-cut in a movie—I found myself in the principal's office. I was being taken to task for not controlling my emotions. She didn't say, "We heard about your father. We're sorry." She didn't say, "We know how awful you must feel." She didn't say, "We know you're in horrible pain." She didn't say, "Someone should teach that asshole kid to be considerate of other people's feelings."

She said, "Young lady, you have to learn to control your emotions."

I felt like screaming: "Control my emotions! Fuck you! My father is in the hospital. He almost died!"

But instead I said, "Yes ma'am. I'm sorry."

And all I could think was, *Oh, Daddy. Poor Daddy. What happened to my poor daddy?*

That night, I stayed with my mother, and she told me everything.

"Is he going to be all right?" I asked.

"He's going to be fine," she said.

"Can I see him now?"

"No," she said. "They're not going to let you in the hospital."

I was very upset, of course, but she made up for it by finding a picture of me and putting it in a little frame and promising to take

it to my father in the hospital. I looked a little like Mother Teresa in the picture, only darker.

The following day, she took the picture to the hospital and set it next to Daddy's bed, and for years afterward that same picture remained on my father's night table, in his room at the house on Parthenia Street.

A few weeks later, Daddy finally went home, and I got to see him, and after that I went to the house as often as possible, to sit with him and keep him company.

One day, his ex-wife Deborah came by to help out—his ex-wives always came through for him, the abuse notwithstanding—and I watched her put vitamin E oil on his burns. I asked him if it hurt, and he said it only hurt a little, and I reached over and began to help. I wasn't afraid to put oil on his burns. I would do anything in the world to ease my father's pain.

A few days earlier, Dad had joked about the incident. "It was an accident, baby. I was eating cookies, and I was dipping them in milk, and there was two kinds of milk. And boom! Motherfucking thing exploded. No one ever told me you couldn't mix two types of milk."

But this time—sitting there with Deborah, helping her put oil on his burns—Daddy decided to tell me the truth. "I was drunk out of my motherfucking mind," he said. "Stoned, too. And I was feeling sorry for myself. And I wanted to die. So I set my black ass on fire."

Not surprisingly, given my father's fame, the whole country was talking about the incident. On the radio. On television. In the streets.

I remember I was in a therapist's office not long after it happened, in one of those sitting rooms shared by several doctors, waiting for my mother to get through another wasted hour of psychobabble, when two patients struck up a conversation.

"You hear about Richard Pryor?" the man said.

"Yes," the woman replied. "You've got to be pretty stupid to set yourself on fire."

"That's what he gets for being such a junkie," the man said. "Drugs really mess you up."

I stood up, furious. "You shut up!" I told the man. "You're a fucking asshole."

"And you're a very rude little girl!" he said, startled by my language. "You shouldn't be eavesdropping on other people's conversations, and you shouldn't talk to people with such disrespect."

"You shouldn't talk about people you don't know with such disrespect." I shot back. "Richard Pryor is my daddy!"

Then things deteriorated. The man didn't believe I was Richard Pryor's daughter, and neither did the woman, and she called me a liar, and my angry screams brought my mother out of her therapist's inner sanctum.

"What the hell is going on here?" she asked, startled.

"She claims she's Richard Pryor's daughter," the woman said.

"They were making fun of Daddy," I said, bursting into tears.

Suddenly, Mom went into Ninja-Mother mode: "First of all, motherfuckers, she *is* Richard Pryor's daughter. Second, you better fucking apologize or I'll mess you up *but good*!"

Needless to say, they apologized.

The next day, when I saw Daddy, I told him what had hap-

pened, and he seemed kind of moved. "Thank you for defending me, Rain," he said.

"I love you, Daddy."

"And I'll tell you something else," he went on. "I'm proud of Shelley. I like the way she went to bat for you, standing up to those honky motherfuckers!"

I smiled. He returned the smile.

"Mothers are very important," he said. "I didn't have much of a mother, but I had Mamma, and you know something?" He lowered his voice to a whisper. "I still talk to her all the time."

"You do?"

"Uh-huh. She's right here, in my head, and she ain't going nowhere."

Years later, when I thought back on that conversation, it occurred to me that Mamma was the only person who had ever really been there for Richard. She had given him the stability that every child craves—she had been his rock and his salvation. I've come to believe that Mamma may have been the only woman Daddy ever truly loved and respected.

I don't pretend to know what was going on in my father's head—I was just a kid, after all—but I honestly believe that in the weeks and months after the accident he was busy reviewing his life. The way he treated women, as if they were all whores. The sycophants that drank his cognac and ate his food and laughed at his worst jokes. The violent mood swings. The abuse. The narcissism. The near-total neglect of the various children he had sired.

He was a total disaster as a man. But here's the thing: as a professional—comic, actor, writer—he was a huge success. And I

wonder if maybe that's what got him through the day. He'd be up there, on stage, strutting, making people laugh, and he'd think, *Those people love me. How bad can I be?*

Maybe a lot of entertainers are like that. You're always hearing stories about this star or that star—they seem so nice on the big screen, but when the camera isn't rolling they are absolute monsters. Now, don't get me wrong—I'm not saying my Daddy was a monster. But I will say this: it was a lot easier to love him if you didn't know him.

Ask the women in his life. I'll bet they'll tell you the same thing. Daddy never got his sorry black ass out of the whorehouses of his childhood. Women were objects to him, without any real value, but they had pussies, and Daddy *loved* pussy. Unfortunately for him, it was a package deal. *Gotta put up with the bitch to get the pussy.*

At least until you got tired of it, which is where the whores came in. Now that was one transaction that Daddy could really relate to. *Why the fuck beat around the bush, baby? All this talk of I-love-you and show-some-respect and I'm-just-trying-to-make-a-decent-home-for-us, Richard—it's all bullshit. A man just wants his pussy. And that goes for every man. And any man who tells you different is a motherfucking liar. And women—they all got their price. Some of the most expensive whores I ever met live right here in Hollywood, in big fancy houses, married to men they hate. Now those are some pretty smart whores!*

I never once saw my Daddy hit a whore. I mean, why would a whore piss him off? A whore was there to fuck. And I know for a fact he respected those whores. I'd hear him talking about them to the hangers-on, between hits on the bong. Whores were *honest.* They weren't there because they loved my Daddy, and they didn't *pretend*

to love my Daddy—they were there to fuck. *Come on, Richard! Bust a nut already! I want to get paid and go home.* Daddy liked it straight, without bullshit. Paid good money for it, too.

That was life with Richard Pryor. Sex and violence, punctuated by rare moments of family happiness.

*It's called fucking, baby! It's what we do. It's all people are good for. And it's fun!*

And *wham! Get the fuck out of my life, you motherfucking bitch. I'm sorry I ever married you! I never want to see your fat ugly ass again!*

So, yeah, he was misogynistic, mercurial, unpredictable, and violent. But he was also my daddy, and sometimes, when he held me close, I looked into his big sad eyes and I knew he loved me.

And that's the part I want to remember.

Not the shit.

I want to remember the love.

And here's the thing: as long as my father didn't think about it too deeply, he was okay with who he was. Maybe even more than okay. Maybe he even liked himself. But when he thought about it too deeply, as he'd done that horrible night in 1980, it almost killed him. So he tried hard not to think about it.

And of course there were moments when he couldn't get away from himself, as there are for all of us. During those weeks of recovery after the accident, for example, I could see he was trying hard to make sense of his crazy life. But I'm not sure he learned much, and, if he did, I certainly didn't see any change.

No. Before long, Daddy went back to who he was, with his roving dick leading the way. He went back to the chaos he'd created—false friends, ex-wives, children he didn't have enough time for, and his whores—always his whores. And he made it work. He made it

work because no matter whom he'd hurt or how badly he'd done it, Richard Pryor always forgave himself. It was a neat trick. If he forgave himself, you had to forgive him too. If he could live with it, you had to learn to live with it, too.

*It's history, baby. It happened but it's over. That was another me.*

And it worked every goddamn time, because a little something came with it: money. That's right, money made everything possible.

In 1983, Daddy signed a five-year contract with Columbia Pictures worth between twenty and forty million dollars, depending on whom you listen to. He was quoted as saying, "I live in racist America and I'm uneducated, yet a lot of people love me and like what I do, and I can make a living from it. You can't do much better than that."

That money bought him hookers and starlets and personal trainers and chefs and psychics and dozens of women, always the women.

And he was fine with it.

Because my dad was still carrying that whorehouse on his back.

*Everything in life—everything—is a transaction.*

It pains me to say this, but when I look back at his life, I don't think Richard ever had one true friend. He paid for his entourage because he needed it. Daddy did not like being alone. When you're alone, you think, and when you think your mind might take you to places you'd rather not visit. You might learn something about yourself, and there's a good chance you won't like it. So no sir, I'll take the *un*examined life any day!

Too bad he couldn't have been a little more like Mudbone, his wino alter ego. Mudbone had an almost magical ability to cut

through the bullshit of everyday life, to tell it like it was. But Mud-bone also knew that people couldn't handle the truth. And neither can I, I guess. The truth is, my father never earned my love, but I loved him anyway. And after his "accident" I loved him even more—loved him so much that I felt that I had failed him. *If I love him enough, maybe he'll never want to die again. If I love him strong and pure, I can save my daddy's life.*

7.

# GET OVER IT

About a year after my father's failed suicide attempt, my mother tried to upstage him. I came home from school one afternoon, and the house seemed dark and eerily quiet.

"Mom?" I called out, but there was no answer.

I moved toward her room, past the creepy photograph of Bela Lugosi, and found her in bed, moaning. Then I noticed there was blood everywhere.

"Mom! Mom! Wake up! Please wake up!"

It looked as if my mother had slashed her wrists, but apparently had had second thoughts about dying, because they'd been ineptly wrapped with scarves. Terrified, I called my grandparents. "Mommy tried to kill herself!" I screamed, trying to stay coherent. "Please come quick!"

An ambulance arrived in record time, and Bunny and Herb showed up a short while later. Herb drove me to the Marina apartment, then went off to the hospital to look in on his daughter.

The following day, Mom was back home.

"I'm a mess," she said.

"No, you're not," I said.

"I'm a total fucking mess."

Of course she was a total fucking mess! She knew it and I knew it. But I didn't think we needed to belabor the point.

I remember promising myself that from then on I was going to be the best little girl in the world, Jewish, black, or *other*. It was an instant replay of what I'd just been through with my father. *If I loved my mother enough, maybe I could save her life. And maybe—just maybe—she'd love me a little in return.*

Man, talk about fucked up!

I don't even know if my father ever acknowledged my mother's suicide attempt. She had been there for him, and she'd even gone to the hospital to give blood, but I don't think she got so much as a phone call from Dad. Life is easy when you don't give a shit about anyone else, and that was Daddy all the way. *Super Narcissist.* He was lost in the black hole of self-absorption.

By this time, Dad and Deborah, wife number three, were history, and I found out that Dad had jetted off to Hawaii with Jennifer Lee and married her. I honestly don't know what he saw in her, and I guess he wasn't too sure himself. A few days later, he said he wanted the marriage annulled. I don't know whether this actually happened, though; she didn't exactly disappear. She had started out as an employee, and she was determined to stick around, and that's precisely what she did. It was a very strange arrangement, and I'm not sure any of us—Dad included—ever understood it.

I hated Jennifer from the very start, and she hated me, but in

Dad bought Mom this fox fur coat after one of their legendary arguments. I still have it.

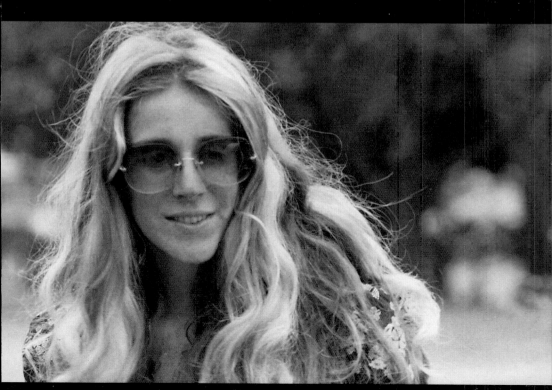

My mother, the Jewish princess. More like the warrior of radical peace. She's going to hate me for saying that.

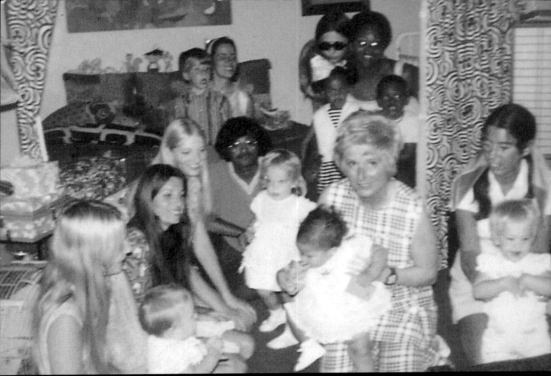

With Grandma Bunny (the kneeling blonde), my aunt Lorie (in the green scarf), and my mother's friends, who were gathered for my first birthday.

Here I am as a baby with Grandma Bunny, Mom, and my great-grandparents, Gus and Sharlet. My grandparents spent a lot of time at the marina. It was a Jewish Yacht Club—what can you expect?

I had the lead in our jazz class recital. I could bust a move even then. Dancing was the thing I loved when being with Dad or Mom got to be too much.

I tried so hard to be a ballerina (*far left*).

With my handsome half brother Richard Jr. and a friend.

My *Saturday Night Fever*–themed birthday party.

I loved the Fonz—note the thumb in the mouth, both cool and comforting.

With my half sister Elizabeth and her mother, Maxine, who never married my father. Maxine welcomed me with open arms.

I loved my rainbow Afro wig. I could create whole worlds that were sometimes far better than the reality.

My half sister Elizabeth and I at the disco birthday party.

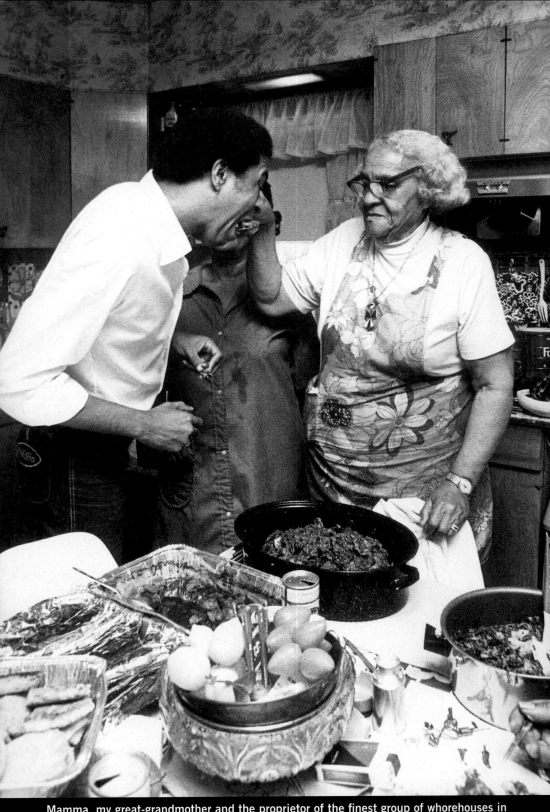

Mamma, my great-grandmother and the proprietor of the finest group of whorehouses in Peoria, always brought stability (and great cooking) to my dad's house when she arrived for long visits.

I loved to go into Dad's closet and put on his clothes because they smelled like him. But his girlfriends kept accusing me of stealing.

Dad was always happiest around the holidays, when his family was around him.

Dad and I taking a nap in 1983. Rare, since there was always some woman lurking around.

Dad dressed as a hobo on *The Richard Pryor Show*.

Me dressed as a hobo for Halloween, with my great-grandparents, Sharlet and Gus, my grandparents, Bunny and Herb, and a friend.

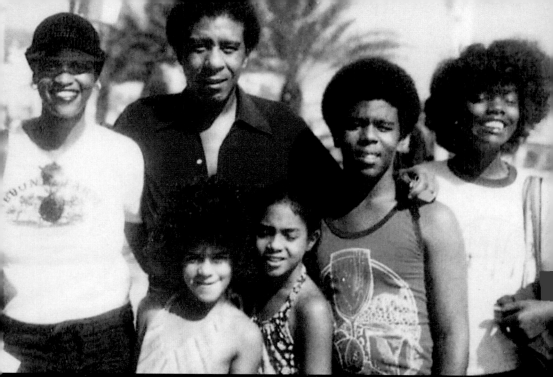

On vacation in Nice, France, in July 1977: Dad's then-wife Deborah, Dad, me, Eliza-
beth, Richard Jr., and Renee (who may or may not have been my sister).

My half sister Elizabeth, Jennifer Lee, me, and Dad getting ready to leave Hana, Hawaii,
on a charter plane. This was after a huge fight in which I witnessed Dad beating Jennifer

The nice Jewish girl graduates from eighth grade. Grandma Bunny was very proud.

As Princess Tiger Lily in my high school production of *Peter Pan*.

With my best friend Gabe Bologna (*at right*) and the rest of the members of our band, Rococo, which lasted a memorable and brilliant four months.

The drill team helped me "get my black back." But in high school I was never black enough, white enough, or Jewish enough.

With my dad at his fiftieth birthday party. The MS was affecting his ability to move about on his own, and his right hand would shake uncontrollably.

Here I am with my dad at the American Comedy Awards, 1993

With my dad on his fifty-fifth birthday. By this time the MS had him completely wheelchair bound. It became more difficult for him to speak clearly all the time. But he did his best.

With my dad at one of our monthly visits in the last years of his life. He was wearing one of those velour track suits, and I thought, *Wait a minute! I'm the Jewish one, not you!* On our visits Dad would have trouble speaking, so we would blow kisses and I'd ask him yes or no questions.

Mom and I go to Disneyland every year for my birthday.

With Mom at Christmas. We truly appreciate each other now, and we love to show it at the holidays.

A stranger took this photo just after Kevin proposed to me on Butterfly Beach in Montecito, California, in September 2001.

The marquee at the Canon Theatre in Beverly Hills for the opening of my show, *Fried Chicken and Latkas*. The show changed my life—some of it great and some of it painful.

the years ahead I had to tolerate her nastiness. In the summer of 1982, for example, Dad took the whole family to Hawaii, Jennifer included, and one night she got drunk and in her incoherence accused me of sleeping with my father. I was thirteen years old and absolutely devastated, so I ran to my father and told him what she'd said. Now, let me tell you, I had seen my father beat the hell out of plenty of women, and I had seen him beat us kids, myself included, but I had never in my life seen him attack anyone with such ferocity. He went absolutely ballistic.

"Leave the room, honey," Daddy said, punctuating his words with a blow to Jennifer's head. "We're just having a little grown-up argument. Nothing to worry about. I just want to make sure this bitch gets her mind right once and for all."

Jennifer was lying on the floor, whimpering, and at that moment I felt genuinely sorry for her. My dad hit her again. "That's right, bitch!" he said. "I'm the head nigger in this house, and you better not fucking forget it!"

My father had a history of violence, of course, but this was beyond violence, and it was beyond comprehension, too. If he hated her so much, why didn't he get rid of her once and for all? And if she hated him, why did she stay? But then it struck me. *No no no. They don't hate each other. Dad and Jennifer are in LOVE.*

I said it a moment ago, and I'll say it again: talk about fucked up!

I decided to try to make the best of life with Mom, and with Herb and Bunny, and I tried to make friends at school. I auditioned as a cheerleader but had trouble with the flips, so I ended up on the drill team. I liked music, too, and I was certain I had loads of untapped talent, so I begged my mother for piano lessons and she finally caved in.

The lesson didn't last long, though. My teacher was a stern woman with pudgy fingers, and she'd yell at me whenever I made a mistake. One day, sick of all the yelling, I yelled right back— "Don't fucking raise your voice to me, you fat bitch!"—and that was the end of that.

Funny what a kid learns from his parents.

In retrospect, though, I think it was more than that—I think it was a case of misplaced anger. I was angry with my father, and I was angry at my mother, but I couldn't yell at them without facing serious consequences. My piano teacher seemed like a good third choice. And it wasn't a total loss, anyway, since I wasn't as musically talented as I'd imagined.

In fact, my greatest talent, back then, anyway, seemed to be my talent for denial. The way I suffered at the hands of both my parents sometimes felt relentless, but I always managed to make excuses for them. *Mom is depressed. Dad is busy with work. It was my fault. They didn't mean it. I should try harder.*

I don't like to dwell on this because it makes me feel like I'm wallowing in self-pity, and because I don't like to think of myself as a victim. It was bad, yes, but I survived. And at the end of the day, isn't that what it's all about?

Plus you have to get over yourself, even if it takes you your whole life—which it kind of does, right? I think, when you've been abused, you spend a good part of your life looking for answers, and you tend to be pretty open-minded about where you look. I've done it all, believe me. Past-life regression. Meditation. Buddhism. Crystals. And I'm *still* looking. But I've learned this much. There comes a point where you have to let it go. If you don't let it go, it will never let go of you.

Even Mamma, whom I loved dearly, once turned to me and said, "Your Daddy beats you cuz he loves you and because you're always fucking up. Now go on. Dry your tears. Get over it."

Get over it. She may have been a whorehouse madam, but she gave good advice.

Get over it.

Hey, I'm trying!

I also suffered through more than my fair share of sexual abuse, including one memorable experience with a guy who was close to the family. Fortunately, Mamma stepped in before anything really happened, but my father took over and proceeded to teach me a lesson by giving me a good whipping.

"What you beatin' me for?" I said, trying to block the blows. "I didn't do nothin'!"

"Yes you did," he said. "You was flauntin' your stuff!"

*Flauntin' my stuff?* The man was truly crazy!

There were several incidents at my mother's house, too. When I was five, she hired a babysitter with two teenaged sons, and they used to give me baths and touch me inappropriately. And five years later I had another babysitter who enjoyed putting gobs of makeup on me and dressing me up like a pint-size hooker. I never told my mother about either experience, because I was too young to understand what was happening, or to even realize that it was wrong, and because I knew it would only get me into trouble.

Years later, in high school, I saw a documentary on sexual abuse, and I was stunned to discover that I'd gone through every single stage described in the film: Guilt. Shame. Self-loathing. Rage. Sorrow.

I didn't blame my parents, though. I blamed myself.

Then I heard Mamma's voice in my head, just like my Daddy used to hear it, and I did what she told me to do: *Now go on. Dry your tears. Get over it.*

When my father was fully recovered from his fiery little accident, he took a trip to Africa. I don't know what he was looking for, but he came back changed. He told people that he would never use the word *nigger* again. *Motherfucker*, on the other hand, motherfucker was okay. As far as Daddy was concerned, that was still a term of endearment.

In 1982, Daddy filmed what he said was going to be his final stand-up show. It was called *Richard Pryor, Live on the Sunset Strip*, and in his act he used the same story he'd told me after his accident: Two different types of milk. A cookie. Explosive results.

He also made another joke to show that he knew what people were saying behind his back. "What's this?" he said, lighting a match and waving it erratically. Then he answered his own question: "It's Richard Pryor running down the street!"

My daddy was one cool cat. "I'll tell you this," he said. "When you're running down the street on fire, people get out of your way."

Richard Pryor was back, and he was badder than ever, and success was not only addictive, it was *contagious*. I wanted some of that for me!

The truth is, I had wanted to be a performer ever since I was born. When I was only four or five, Daddy gave me a rainbow-colored Afro wig and a microphone and told me to go wild, and

Opposite: *Richard Pryor: Live on Sunset Strip* (1982)

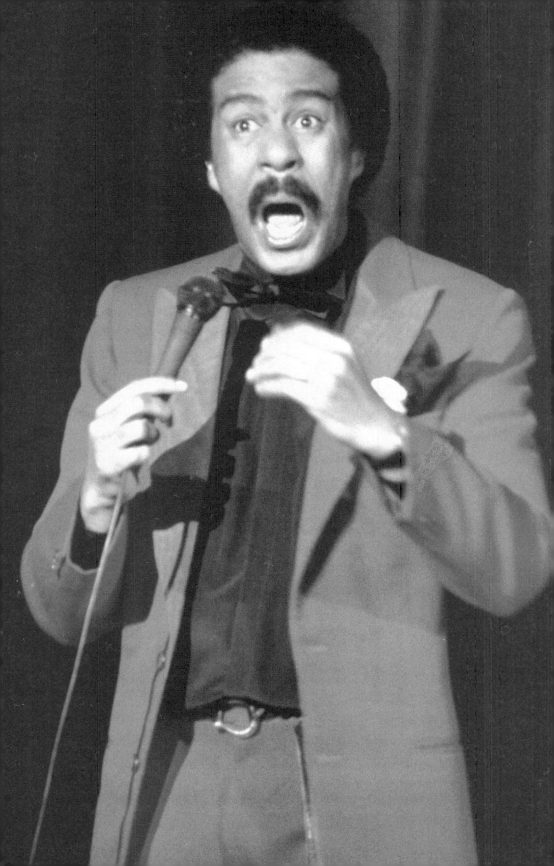

when I was six I got a small part in an amateur production of *The Wizard of Oz.*

I loved acting, and I knocked myself out, auditioning for everything that came along, but it was tough going. All through grammar school, I got parts in the school plays, but they were never the parts I wanted.

Still, the entire family supported me. Mom, Dad, Grandma Bunny, and Grandpa Herb came to almost every single one of my performances, acting like a regular family. I don't know what it was, or why—maybe because all of them were in show business—but there wasn't a kid in that school who had a louder cheering section than me. My family made me feel that I was Josephine Baker, Ethel Merman, and Katharine Hepburn—*combined.*

And of course everyone knew who my daddy was. And if they didn't, his loud, raucous laugh got their attention soon enough.

When I was twelve, I landed a role in a professional production of *Runaways,* a musical by Elizabeth Swados, an award-winning playwright. I was convinced I was on my way. The following year, seeing that nothing much had happened, I concentrated on pop vocals and opera. If I wasn't going to act, then by God I would sing.

My parents really believed in me, and my father paid for me to attend the Interlochen School of the Arts, in Michigan, where I studied acting and singing two summers in a row. We had to wear uniforms—powder blue polo shirts and blue knickers, with loafers and calf-length socks—and I loved the feeling of *belonging.* I made a few friends there, and I got my first crush on a cute boy, and I did what a lot of girls were doing at age thirteen—writing in my diary.

I had received one as a present the previous Christmas—it had one of those big B. Kliban cats on the cover, under the words, "These

secrets are protected by a fierce and ferocious cat!"—and I had started writing in it almost immediately.

Unfortunately, I still have the diary, and I am now going to subject you to some entries, dating back to 1982. I addressed my entries to Myrtle, my land tortoise, which continued to survive and thrive over on Parthenia Street, but I wasn't much of a speller, and I even got the turtle's name wrong.

The themes, if you can call them themes, are not particularly surprising: I was upset with my mother, who drank too much and always argued with me and blamed me for everything. I was upset with my father, who always promised to spend more time with me and never did. I hated homework, and there was too much of it. My hair was unmanageable. And, finally, my life was boring.

That said, a few of my ramblings follow, unedited.

JANUARY 1: I had a realy great time in Hawaii. The people are so nice. It's the first time in my life that I every felt close to him. But I realy do with that with [wish?] that me and my sister Elizabeth got along better it would have realy been even more great. I with surly miss all though that I miss has left behind. Because finally in my life a had niece friend.

JANUARY 9: Today was great me and my mother just went cut we saw a movee it was called victor Victoria. It was realy funny. But oh let me tell ya when we got into the teater these lady sitting in back of use were being realy rude. They were talking about the bun on my head and about the way my mom ate fried zukini. They were real Jewish yenta's. I couldn't believe it. Sorry it's a very short day but there will be more.

JANUARY 12: That jerk I was telling you about toled me I was a 60s reject I could have slapped the nerv of that creep. Oh my mom got a job this wonderful holiday. That makes me kinda sad well. In school we are learning about slavery. It hurts inside to know how people could take atvantage of someone who's different from them but I guess my pain doesn't matter anyway.

JANUARY 13: Today that jerk called me a reject so I called him a poser so he decided to call me a nigger. [Author's Note: I'm not sure which lame boyfriend I'm talking about.] My friend and person my mom most admired called me a nigger what a asshole! My body was totally parilized. I had dinner at my grandparents' house and I slept over. I realy can enjoy my grandparents sometimes—oh fame was to good to night it was realy touchin Oh well another short day.

JANUARY 22: I'm not suppose to write but I am. I've been cooped up in bed all day. Do you know how boring that is! I hardly can't wait at 3:00 my daddy is coming to see me it really means allot to me. My mother realy seems nervous and uncomfortable. She has kinda an attitude. Well any way they got along. He bought me a bunch of juices and lots of candy well bye.

JANUARY 23: Another boaring day and boy is my butt sore. My arm was realy buggen me last night. I could hardly sleep. My dog Flopy is realy horny. You see his [penis]. In a state where he needs a girl friend. My dad came again today, except this time we had lots of fun. My aunt was there and all. My mom and

dad had a long talk it was quite a nice one she said. I think its good that my mom and my dad are opening up to each other. Well bye.

JANUARY 29: Today I woke up bright and early watch tv. And had an argument with my mom. At 12:45 my dad come to my house and toled me that today was my day. I said I wanted to go into Westwood and see a movie. I said I wanted to see Tootsie but instead we saw his movie Time Rider. Then after I said I wanted to get tapes but instead we went to pick up his girlfriend. The we went to eat a Rock o Roll resterount. He said the reason he was upset is because I made my sister go home.

FEBRUARY 2: After school today I got my hair colored hot pink. It looks pretty good. Boy do I feel good about the way I look. I was supposed to get my period today but I didn't but that's ok its only my third time, me and my mother got into a big fight it all started like this when I got home From getting my hair done I put my close in the wash to be cleaned but I didn't know there was other stuff. Mom got mad and yelled I called her ass__
Boy do I feel like an ____

Okay. Not exactly fascinating, I admit, but if nothing else it helps you see what a long way I've come. And I never said I was a writer, anyway. I'm an *actor*.

The acting bug stayed with me all through high school, and I tried out for all those plays with similar results. I began to feel I wasn't quite as good as my family thought I was, and it depressed

the hell out me, and then my teenage hormones kicked in and I kind of lost my mind.

It was minor stuff. Drinking. Smoking a little dope. Sneaking out of the house in the wee hours to go dancing at underage clubs.

But I'll tell you this: Daddy wasn't too happy about the fact that I was turning into a young woman.

*Where you goin' dressed like that, girl?! Put a turtleneck over them teenaged titties! Put a scarf over your head like them women in Afghanistan. Okay, that's better. And don't smile at nobody neither, or I will kill you and make you wish you was white. Okay. That's all. The Great Nigger has spoken. Now go out, but don't have too much fun.*

My father was busy making movies, and making money, but he didn't seem all that happy. The old energy was gone, and looking back I think it may have had something to do with the quality of the work.

He was in a movie called *The Toy*, for example, in which he plays a guy who is purchased as a toy for a rich man's spoiled son. The reviews were lousy, and one reporter even said that Daddy had lost his edge. I don't know if that pissed him off, because I don't know if he read the reviews, but I know it pissed *me* off, and I began to have serious doubts about this whole acting thing.

I decided I was too cool to be an actor, so I started hanging out with the too-cool crowd at an underage dance-club in Santa Monica. Sometimes my grandpa Herb would drop me off, saying he'd be back in two hours, and I would race inside and dance and flirt with boys and smoke clove cigarettes. When I emerged from the club, two hours later, Herb was always waiting for me in the exact spot where he had dropped me off, and it finally dawned on me that he never left. I think he was worried that something might

happen, and I guess he wanted to be on hand if he was needed. He would wave when he saw me coming, and I'd wave back, kind of embarrassed, the way kids tend to get, and when I climbed into the passenger seat he always said the same thing: "What is that smell? You haven't been smoking, have you?"

"No," I said. "But some of the bad kids smoke, and it gets on my clothes."

That same year, my mother got a job in Tahiti, with Club Med, the resort people, and I got a short break from Hollywood (and everything it represented). She was an activities coordinator for the

With Teresa Ganzel and Jackie Gleason in *The Toy*.

organization, and she really enjoyed the work, and I got to be a kid for a while. I learned how to snorkel and water ski, and I had fun doing it—partly because I didn't feel like such an outsider in Tahiti. Nobody seemed to care about the color of my skin, or about my religion, or about anything else for that matter. I was just a kid, and my job was to be a kid, and I did it admirably.

Toward the end of the summer, when it was time to go back to the States, where I was supposed to start freshman year at Beverly Hills High School, my mother suggested that we stay. She could continue to work, and I would go to the French school in Papeete, the neighboring island. I could either commute by boat, or we would find a French Polynesian family to take me in during the week.

While we were considering this, Mom got a second, part-time job on the island of Bora-Bora, where she met the king, with whom she proceeded to have a torrid affair. She claims that the king proposed to her, and I don't disbelieve her, but things didn't work out—for reasons that remain unclear—and we headed home. Still, for a short time I wondered what it would have been like to be the princess of Bora-Bora.

Before we left the island, I lost my virginity. I report this matter-of-factly because it was kind of matter-of-fact, despite the unusual circumstances: my virginity was taken not by one boy, but by two. And they weren't just boys, they were brothers. And they weren't just brothers, they were twins.

I have to say, though, that it was unexciting in the extreme—but I was glad I did it. Losing my virginity seemed like something I needed to get out of the way, so that when the time came, and I was genuinely interested in having sex with someone, I wouldn't have to worry about the technical details.

And that's all it was, really. Sex wasn't much of a mystery to me. By the time I was ten, I'd seen just about everything you can imagine—and some things you probably wouldn't want to imagine. I'd walked in on oral sex. I'd watched my dad having threesomes. I'd seen men chasing naked whores through our living room on Parthenia Street. And I'd watched my daddy beating women up *while* he was having sex with them.

It didn't loosen me up, though. On the contrary—that hyper-sexed atmosphere had the opposite effect. I grew up feeling awkward about my body and uncomfortable with nudity. I was so confused, in fact, that for the longest time I didn't see the connection between sex and love.

It's strange, because both my parents thought it was "hip" to be open about sex. My dad had told me when I was five that *fucking was fun.* And a year later my mother was sitting on my bed, flipping through a book called *Show Me,* which was filled with close-ups of naked adults touching themselves and touching each other. I remember thinking, *Eeeew, this is so gross! Please don't make me look.* But my mother was such a goddamn flower child that she thought she was doing me a favor. *Mom! Hello! I'm six years old! Can I have a few years to be just a kid?*

Sometimes, when I think about the two people who brought me up, I wonder how I survived.

When you become a parent, as I understand it, your whole center of gravity shifts, and suddenly your children take center stage.

But that never happened in my case.

In my case, Mom and Dad always came first.

## 8.

# BEVERLY HILLS HIGH

When my mother and I got back from Tahiti, Daddy suddenly of-
fered to buy us a house. There was no explanation—"I want to buy
you a house"—and we didn't push for one. We were over the moon
about it. We were finally going to make the leap from renters to
homeowners, and it was a big, joyous leap.

After several weeks of looking at real estate, we found a place
on a quiet cul-de-sac in Studio City. It had a big fenced-in yard
that pressed up against a dense grove of trees that for some weird
reason reminded me of Sherwood Forest, where—as legend has
it—Robin Hood hung out with his merry *brothahs*. When the real-
tor showed us inside the house, however, I took an immediate dis-
like to the place. I told my mother that the house had a bad vibe,
and that the previous tenants had hated the place. I don't know
what made me say that, but it was a strong feeling, and I thought
I should share it with her.

My mother didn't listen. She thought the place was perfect. "It's

just right for a nice, classy, well-to-do family," she said. "I'll even get you a dog."

I didn't understand what she meant. If it was right for a nice, classy well-to-do family, what the fuck were we doing there?

When Mom called Daddy to tell him about the house, there was a major glitch. "I ain't gonna buy you that house unless it's in Rain's name," he said. And when I got on the phone he repeated the same thing: "I'm not putting it in your mother's name, baby, because I don't want her getting it."

My mother was very upset. She didn't want to put the house in my name because she was sure I'd kick her out the moment we had our first argument. I told her she was wrong, but she wouldn't listen. She wasn't willing to live with that kind of uncertainty. She kept badgering Richard to be reasonable, but he refused to change his mind, and our short-lived dream of homeownership came to an abrupt end.

For me, it was no big deal—I was just a kid, about to start freshman year at the infamous Beverly Hills High School—but for my mother it was a complete disaster. As far as she was concerned, the whole world was against her, and she was condemned to spend the rest of her miserable life in low-rent housing.

She was depressed for weeks, but she emerged from the fog, briefly, to help me get ready for school. "It's going to be a lot of fun," she said sarcastically. "Get ready for all the bitch shit."

*Bitch shit?* I didn't know what she was talking about, but I found out soon enough.

Opposite: With my friend Sheila (*center*) and another girl. Note the fabulous eighties fashions.

My goal, even then, was to become an actor, as it had been for many years, but I knew I had to get through high school first. I imagined it was going to be a lot fun, but I imagined wrong.

The "bitch shit" my mother was referring to—adolescent mind games—had been raised to an art form by the girls at Beverly Hills High. Every girl had an opinion, and they weren't shy about expressing it.

Here was the assessment from one of my Jewish classmates: "Oh my God, Rain! Your hair is HUGE. I can barely see myself in the mirror through your BIG HAIR. Like what do you keep in there, anyway? Like is it true that you people put plastic on your couches because you're afraid the grease from your hair might stain the upholstery?"

And after I had the audacity to ask about a cute boy in our class, this was the choice response from another of the Chosen: "You like Joshua? You can't be serious, Rain. He likes Jewish girls, and, like, duh, I'm Jewish and you're not. . . . No, you're not. Just because you know all the songs from *Fiddler on the Roof* doesn't make you Jewish. What? You say your mother's Jewish? Well, first of all, Jewish women don't marry blacks, and, second, there's no such thing as a black Jew."

I guess she'd never heard of Sammy Davis.

Once again, I was quick to get the message. In grade school, I'd also been told that I wasn't neither Jewish enough nor black enough. Now that the Jews had been so quick to reject me, I pinned my hopes on the *sistahs* and figured the only way to win them over was to be totally *street*.

The first two *sistahs* I met, Page and Sheila, were on the drill team, and they urged me to join.

"You *gotta* be on drill team," Sheila told me. "Get your black back. All the movin' and groovin' will set you free."

So I joined the drill team, wowing everyone with the skills I'd honed in grade school, but the *sistahs* weren't impressed. I wasn't black enough. I was barely as brown as a paper bag. "Girl," Page told me one day, "you so bright I need sunglasses just to look at you!"

That fall, my daddy came to school to watch me in a play, and for a brief period the *sistahs* stopped giving me a hard time. To know I was Richard Pryor's daughter was one thing, but seeing him in the flesh, in the audience, laughing his big laugh, was something else altogether.

For a while, Sheila and I actually became quite close. We would go visit Daddy—she got to see Richard Pryor, in his own house!—and she was understandably starstruck. But that passed, too, alas. Before long, Sheila was saying, "Well, your daddy's famous. Don't make *you* famous."

Fuck her. Someday, I was going be famous, too.

But I had to get through high school first, and so far I wasn't having much fun. I hadn't found my place in kindergarten or in grade school, and these kids were worse—bigger and meaner and even more exclusionary.

For a time, in a desperate bid to be accepted, I played chameleon again, and at one point I tried dressing like some of the girls. At first, I went for the freshman preppy look: pleated skirts, button-down shirts, and knee socks with loafers. Didn't quite cut it, though.

Then I morphed into an eighties girl: big hair, leggings, and off-the-shoulder *Flashdance*-style tunics. Sorry, girl. Try again.

I had fun, briefly, as a neo-trash hooker: skintight tank tops, tube shirts that doubled as micro-miniskirts, and high heels that

would have looked good on my father's whores. Local construction crews seemed to like the look, but the girls at school didn't respond.

Finally, I gave up. I figured nothing gave a girl cachet like a genuine boyfriend, so I decided to find myself a man. Gabe Bologna was one of the very first guys who took the time to talk to me, and I thought I was in love, but he told me he wasn't interested in me "that way," and so I decided to settle for his friendship. We remained close all through high school, and I spent so much time at his house that his parents—Renée Taylor and Joseph Bologna, the actors—became like second parents to me (although "second" implies that I had *real* parents, and to describe Richard and Shelley as parents would be a disservice to decent parents everywhere).

Sophomore year, I developed a mad crush on Gabe's friend, who also wasn't interested in me, not in "that way," anyway. Then I fell for Adamo, who was as uninterested as the other guys. It hurt, of course, because I was young and insecure and desperate to be loved, but the friendships survived, and I realized that they obviously liked *something* about me, so I couldn't be all bad.

Slowly, I befriended a number of girls in my class. We weren't the coolest clique in school—quite the contrary!—but we were certainly cool enough for each other.

I came to rely on my high school friends. Whenever things with my mother became unbearable, I always had somewhere to run. You know the kid in high school who's always looking to crash at the homes of other kids? Well, *I* was that kid.

One day, out of the blue, and for no apparent reason, my mother took me to a roller rink in Reseda, in the San Fernando Valley. I

remember wearing spandex pants and a red tube top that kept slipping down because I had no boobs, and I remember that I was grinning the whole time—skating and grinning and laughing. For years afterward, my mother made a special effort to take me skating from time to time. I guess she had seen how happy it made me, and that made her happy, too, so she'd put her troubles aside and we'd pile into the car and off we'd go, and sometimes we'd invite friends to come along. Cher came once or twice. So did Jim Brown, who was friendly with both my parents. And once in a while I'd even bring a friend from school. Sometimes, if she was busy, she'd drop me off at Flippers, in West Hollywood, just like a regular mother, and I'd skate on my own,

One night, senior year, we went to a Valley disco and danced together. I've got to admit, she was a pretty good dancer. The place was also open on the weekends, and sometimes I'd beg her to drop me there when it opened, at eleven in the morning, and I'd stay and dance till six at night. One thing I know about myself for sure: when I'm dancing, nothing can trouble me. When I'm dancing, everything's right with the world.

One of my best high school memories has nothing to do with high school at all. It was my Sweet Sixteen party, which was held at the Del Rey Yacht Club, in the Marina, on May 19, 1985.

My mom was relatively together by this time, having worked to make it happen, and my grandparents helped out, too. Herb and my father covered the expenses, and Grandma made sure it was catered.

We had the party two months before my actual birthday, before my friends scattered for the summer, and for some crazy reason I decided to turn it into an all-girl party. The night of

the party, though, when the guests began to arrive, I suddenly had second thoughts. "I wish I'd invited the guys," I told my mother.

"But honey," she said, "you said you wanted a very girlie sweet sixteen!"

"I know," I said. "But it seems silly now."

It was fun, anyway. My girlfriends were all there, along with my half sister Elizabeth, and we spent the first hour inspecting each other's outfits, giggling insanely, and eating everything in sight.

Then I got the surprise of my life: Somebody cranked up the music—Cyndi Lauper's "Girls Just Want to Have Fun"—and three girls I didn't recognize sashayed their way through the door, shaking

At my sweet sixteen birthday party. The lovely girl behind me is Gabe in drag.

their booties. They were terrible dancers, and, as it turned out, they weren't even girls. They were my three best male friends, Gabe, Jason, and Adamo, "crashing" the party in full drag (at my mother's request).

My dad came, too, of course, and I sang a little song I'd written for him, accompanying myself on the piano, which actually moved him to tears, and when it was over my mother asked people to sign the little guest book she's set on a table near the door. She wanted to remember, and I have that book to this day.

"Rain, today is but YOURS," my father wrote. "Sweet 16. I love you. I wish I could spell, Baby, so I could write all the fine things about you this day."

Elizabeth wrote, "I want you to know that no matter what, I'll always be here."

The boys also weighed in: "I'm not a transvestite," Jason assured me. "You're the only one I'll dress like a woman for!"

Gabe said, "I look like a putz in girl's clothing. I love you. I hope you still like me even though I am a lesbian."

And Adamo fessed up: "It is true. I AM a lesbian . . . I think you are a great lady and you deserve the best."

My mom also wrote in the book: "Rain, beautiful Rain, I love you so. I am so proud of you—on this day my heart is so full. You have the magic . . . you have the music . . . You can have the world if you want it. Rain, in all my secret dreams, I couldn't even dream up a daughter as wonderful as you."

It was a rare and perfect day, and I will never forget it. It reminded me that there were times when my mother and I were everything a mother and a daughter could be. You seldom see those things when you're a kid, but you see them later—when you grow

up. But you can't go back in time and tell them, *I know you loved me, Mom. I know you did your best. I love you too.*

That summer, I went to Idylwild, another performing camp, this one closer to home, right there in Southern California. I was cast as Anita in *West Side Story* and came away from the experience determined to make it as an actor.

Junior year I got cast in an elaborate Beverly Hills High production of *Peter Pan*, as Tiger Lily, and it was such a professional production—down to the wires and harnesses that let us fly through the air—that I just *knew* I was going to spend the rest of my life acting. It also helped that my father attended the performance, and praised me to no end. "Good work, baby," he kept saying. "Real good work. You obviously got the stuff."

After an academically dismal junior year, Daddy pulled some strings and arranged several auditions for me, including a stab at a part in *The Bingo Long Traveling All-Stars and Motor Kings*, which he was in. I didn't even land a walk-on, and I figured I must have been pretty bad if Richard Pryor couldn't get me a part in one of his own movies!

By senior year I was barely scraping by academically, but I was still pouring my heart and soul into acting. I got the plum role of Rizzo, in *Grease*, but got pulled from the production at the last minute because of my failing grades. That was a very painful and humiliating experience.

I found myself spending more and more time with the bad-ass black girls. We'd go down to the 'hood, and share that sickening fortified wine with some genuine gangbangers, until "the shit put us on a tilt." I swear to God, that wine was *evil*. I remember falling asleep *on my feet*!

The girls and I also spent a little time in Venice, entering dance competitions at the famous pier, and on weekend nights we'd hit the clubs and drink and buy a little dope. One night, some friends and I made the forty-five-minute drive to Magic Mountain, the amusement park, and one girl got pretty stoned. She wanted to go to a gang party in Compton, and I refused. She called me a pussy and worse, and I left.

The next morning, at school, the argument escalated, "I'm gonna kick your ass, bitch, and then I'm going to kill you."

*What the hell?!*

"You gonna kill me?" I said. "Well come on, then, *bitch!*"

I had a little pocketknife with a one-inch blade, and I whipped it out and went hard-ass on her.

"You're crazy," she said.

We ended up in the principal's office, and I got endless shit from my mom as a result, but it turned out to be a good thing. I figured girls were nothing but trouble. They either rejected you or got you into shit you had no business getting into. Maybe it was time to give the boys another chance.

Within a few weeks, I was dating Larry, a gorgeous half-Mexican guy, and one day I took him out to Parthenia Street to introduce him to my father. Daddy walked into the living room with a shotgun in his hand and looked Larry in the eye and said, "What are your intentions with my daughter, young man?"

Larry turned a little pale—well, *pretty* pale for a half-Mexican guy—and a moment later my father was laughing. Larry didn't find it all that funny, though. He said my father had a weird sense of humor. "That's what he's known for!" I said.

Not long after that, I got into another in a series of horrible

arguments with my mother, about God knows what. I decided I should kill myself, so I swallowed half a bottle of Tylenol and immediately called Larry.

"I've taken a bunch of pills," I said dramatically. "It's all over!"

Larry came to the house but didn't know what to do with me, so he drove me back to his mother's place. "Rain, Rain—chew moost trow up dee pills!" she said in her broken English. "Chew moost try to *bomitar!*"

I tried to vomit, but nothing came up. "I'm actually not feeling all that sick," I said.

She was still very worried, though, so she called my mother and they agreed to meet at Cedars Sinai. Mom was waiting for us when we got there, outside the emergency room, looking terrified. I remember thinking to myself, in my addled, adolescent way, that maybe she loved me after all.

The doctors, unimpressed, sent me home and told me to sleep it off, and Mom called Daddy that night to tell him what had happened.

The next afternoon, Dad phoned and told me to come over. When I got to his house, he asked if I'd seen what was in the driveway.

"Not really," I said.

He took me outside and pointed at a brand-new Nissan. "That's for you," he said. He never said a word about my little suicide attempt.

"Wow," I said. "A car? For me?"

"All yours, baby."

"What should I do with it?"

"What do you mean, baby? It *yours*. Drive it home!"

I had been taking driver's education, so I knew how to drive a little, but I didn't actually have a learner's permit. This didn't seem to bother Dad in the slightest, though, so I thanked him, gave him a little peck on the cheek, and drove home in my new car.

I didn't hit a single person and didn't even have a single near miss, but when I got home my mother went absolutely ballistic. She called my dad and screamed at him. "She tried to kill herself! She doesn't need a car. She needs *help!*"

I don't think my father really understood this business about "help." *Didn't the car help? Wasn't that a nice thing? Would it take a cooler car to keep Rain from wanting to kill herself?*

My father could only really relate to his own needs. Where other people were concerned, gifts and money did the trick. He didn't realize that a nice solid hug would have done a lot more for me than a new car.

In 1986, while I was still a senior, my father married his new girlfriend, Flynn Belaine, whom he'd met on the set of a recent movie. In a matter of months, he and Flynn would divorce, but they remarried again a few years later, and their rocky relationship provided two new siblings for me, Steven and Kelsey.

Once again, my father had never even bothered to tell me that he was going off to Hawaii to get married. I had to read about it in the local paper, along with the rest of the world, and I didn't always like what he said—especially when it was about the family. In one recent interview, for example, he told a reporter that he wasn't crazy about the way his kids were turning out.

Man, that *hurt*.

I remember sitting down to write my father a letter, to tell him exactly how I felt about all of this, and I remember crying as I

wrote the letter, but I never had the courage to mail it. I kept it, though. And here it is:

Dear Father,

Things at home are o.k. but life is not.

I cannot believe that you didn't call me back or even give me your new number. You treat me like a stranger. I am your blood, (even if I was a misfortune), not a fan.

I could care less about your money. All I ever asked for was your time and love. But no, you gave up and gave in. You didn't even try. You seem to always find time for women. You have yourself a hell of a rep. . . . You write about us (in the paper). Here's a quote: "I don't like the people my children are becoming." Or this one: "I want to get married again some day and I want me and my wife to decide on when we have kids."

It's funny how you never take responsibility for your actions. You just blame everything on the women or your drugs. Now that you don't take drugs who are you going to blame now? Don't you know every time you point at somebody or something you've got three of them suckers pointing right back at you?

I have spent 17 years hurting inside from you. You really haven't given me anything to let me know that you care. I may mess up sometimes but I've never really screwed up. I've never O.D'd. on drugs or gotten kicked out of school for cheating. I've messed up normally. Like not doing well in school or being obnoxious at home. But never once have I really been falling down. . . . I am Rain: musician, actress, singer, dancer. Stop trying to avoid my existence on this planet.

I mean, when are you going to get down off of your high horse and get involved? I've been there for you. I was willing to try. I gave you my love but never once did you give your love to me.

I don't know what makes you think you're so damn special. Sure, you're a star, but so is Rob Lowe. You're not all that great to me. That's only because as a person you are not special. It's funny how a stranger falls in love with you but someone who really knows you wouldn't dare take the chance. Yeah, and you're a great actor. But the show you've been putting on for the last 17 years of my life has drawn its last curtain.

Have a great marriage and maybe if she doesn't see the real you she'll stick around.

—*Rain*

9.

_____

# AN ACTOR'S LIFE

Richard Pryor doled out a lot of crap in his life, especially where women were concerned, but somehow his ex-wives and his ex-girlfriends and his sometime-flings always forgave him, and a number of them formed this weird sort of Richard Pryor Fan Club.

There were many trips—notably to Maui—where ex-wives and ex-girlfriends were invited to come along with their children. They were generally housed in the same hotel, on the same floor, if possible, and they would sit around sharing war stories and laughing at the memories, though I know some of them were pretty goddamn painful. I think the women in Richard's life took solace from these joint vacations. Years later, I imagined them forming some kind of support group that would meet once a week in the basement of a local church. As you entered, you would see two signs: *AA, Room 111. Former Wives of Richard Pryor, Room 113.*

It was a pretty crazy family, and no one ever bothered to explain the entire cast of characters. Some years ago, though, I asked my

half sister Elizabeth to help me work out how we were all related, and we came up with this:

Daddy was married seven times to five different women, and he had seven children—seven we know of, anyway. The wives were

PATRICIA PRICE, 1960 to 1961. One child, Richard Jr.

SHELLEY BONIS, 1967 to 1969. One child, Rain.

DEBORAH McGUIRE, 1977 to 1979. No children.

JENNIFER LEE, married for fourteen days in 1981, and, according to Jennifer, again in June 2001, until his death. No children.

FLYNN BELAINE, 1986 to 1987, and again from 1990 to 1991. Two children, Steven and Kelsey.

As my father once said, "I believe in the institution of marriage, and I intend to keep trying till I get it right."

Then there was another child, Renee, who predated all of us, and who may or may not have been Daddy's daughter, and there was of course my closest sib, Elizabeth, who was the daughter of Maxine, another nice Jewish girl, like my mom, but one who had the good sense not to marry Richard.

Last but not least, there was Franklin, who came along at about the same time Kelsey was born, but to a different mother. Way to go, Dad!

Sad to say, every single one of his wives accused Richard at one

Opposite: Elizabeth and I joke that we're the only ones who know what it's like to be the half-Jewish daughter of Richard Pryor.

point or another—and often more than once—of domestic abuse. But Daddy was either made of Teflon or very good at talking his way out of trouble: the charges never stuck.

In 1986, my final year in high school, the same year Daddy married Flynn, the same year he shot *Critical Condition* with Gene Wilder, my daddy got sick. He began getting headaches after sex, and it bothered him enough to have it checked out. I'm sure if it hadn't been related to sex, Daddy would have ignored the symptoms until they literally felled him, but sex was sacred territory, and something needed to be done.

Doctors put him through the usual battery of tests, and they discovered some scarring in portions of Daddy's brain. They broke the bad news. He had multiple sclerosis. The doctors explained that MS was an autoimmune disease in which the body attacks its own nerve cells, destroying the protective sheath around each nerve and making it impossible for the cells to communicate.

Daddy listened, and he shared the bad news with us, but none of us really understood it. He had occasional headaches, yes, but in every other respect he was the picture of health. We didn't think it could be all that serious. Plus, as the doctors had told him, the disease was progressive, and it progressed at different rates in different people.

I remember thinking, *Daddy's going to be just fine.*

For a long time, Daddy asked us not to talk about the illness with anyone. He was a Hollywood actor, after all, and if any of the higher-ups in the studio system even suspected that he had a degenerative disease he would have found it impossible to keep working. That's the town for you—all heart.

"Can't let these motherfuckers find out or I'm *really* finished," he told me.

"Come on," I said. "These people can't be that bad."

"They're *worse* than that—worse than you can imagine," he said. "You got to keep these fools close enough to see the shit they're up to, and far enough so they never see the real you."

As the disease progressed, though, he couldn't hide it anymore, and a handful of his classier friends came by to visit—Arsenio Hall is one of the few I can remember. Others sent cards with the usual good wishes. The vast majority, however, did absolutely nothing. Just like the town—they were all heart.

There were plenty of people around the house, though, ready and eager to help. Flynn was there, and Deborah visited regularly, and for a long period I was there almost every day.

Watching my father get worse was absolutely terrifying, and I dealt with it by trying to learn everything I could about the disease. As his doctor had told him, it affected the nervous system, attacking the nerve fibers that allowed the brain to communicate with the rest of his body. In time, Daddy could expect endless misery, which would manifest itself in myriad ways—numbness, tingling, muscle weakness, spasticity, cramps, pain, blurred or double vision, muscle weakness, blindness, incontinence, slurred speech, loss of sexual function, loss of balance, nausea, depression, short-term memory problems, trouble swallowing, even trouble breathing.

There were several types of MS, and some forms were apparently pretty benign, but it was clear that Daddy didn't have one of those. He was in trouble. He knew it, and we knew it.

Worse still, as I discovered, there was virtually nothing anyone could do for him. Researchers were working on finding a cure, and they were making progress, but not enough to give us hope.

When high school finally ended, I actually moved in with Dad

and Flynn. Mom and I were again having trouble getting along, to put it mildly, and it just seemed like the smart thing to do. Plus they liked having me there, especially when I made myself useful as a babysitter. And I liked being there—it made me feel that I was watching over Daddy.

I also went to visit my grandparents from time to time. Grandpa Herb would take me sailing on his little sailboat, *Rainflower*, and we'd return to the house just in time for dinner. Grandma Bunny cooked these elaborate, multicourse meals, and she always shared her secret recipes with me. "I give them to other people," she confided. "But sometimes, if they're not so nice, I leave out a key ingredient."

At my high school senior luncheon with Mom and Grandma

I had my own life, of course, and I was eager to get my acting career off the ground, so two or three times a week I'd race off to some audition or other, hoping to be discovered—like ten thousand other equally naive young ladies. At one of these auditions, I met Ronnie Yeskel, who was already on her way to fame as a casting director, and she introduced me to Josh Schiowitz, who was both a playwright and a theatrical agent. Josh got me an audition for *Head of the Class,* a hit television show, and I nailed the audition.

For many years, I had been creating characters in my head, partly as an acting exercise, and partly for my own entertainment. One of the characters was a pseudo gangbanger named Wanita, whom I'd based on some of the wannabe tough girls at Beverly Hills High, and I knew her as well as I knew myself. (Or maybe even a little better!)

When I showed up for my audition, I launched into Wanita's hostile rap routine—*I will cap your ass, motherfucker!*—and the humor really worked. The producer called that night to offer me a recurring guest spot on the show, as T. J. Jones, but said they were going to rework the character to make her more like Wanita. Needless to say, I was both elated and flattered.

The show, which starred Howard Hesseman, previously of *WKRP in Cincinnati,* was about a group of high school kids who were too smart for regular classes and, as a result, become isolated in this "brain tank." Hesseman played the kids' laid-back history teacher, and when he left the show he was replaced by Billy Connolly, the Scottish comic.

I was a little nervous during the first day of shooting, especially since most of the actors had already been doing the show for three years, but on my very first day, I got a standing ovation from the stu-

dio audience, and that changed everything. I was the only member of the cast who had brought the audience to its feet, and I'll tell you—when I walked off the set, I was as high as I'd ever been. Acting, I realized, could become very addictive.

I really liked my character, too. T. J. was an aggressive, tough-talking girl with a loud, hostile personality, but deep down she was vulnerable and highly intelligent. She reminded me of me a little, of course, because the writers had put a lot of Wanita into her, and playing her came pretty naturally.

I loved the way she talked, and I got plenty of help in that regard from the talented writers. The day T. J. learned she was getting into the brainiac class, for example, she had this to say: "Well, isn't that a

With Robin Givens and Howard Hesseman in *Head of the Class*

dream come true? Sit in a nice, clean desk with no dirty words carved in it, everyone dressed like it was Easter Sunday, and a teacher who treats you better than your own mama. And a hour later I get sent back to the real world—and that's the last I see of Disneyland!"

T. J. also rapped pretty good: "Girl in the streets, no clothes and no heat. A crazy outlook, a torn-up book, but she can compete. Girl on fire with her desire seeing stars there and bars there. Should go much higher."

At the end of my first season, Daddy came to visit the set, and you would have thought Elvis Presley had returned from the grave. He watched us tape an episode, and when it was over the entire staff lined up to meet him and shake his hand. When it was time to go, I walked him back to his car, and he turned to me and said, "You were good, baby. You were real good. Definitely got the stuff."

It was nice to know he wasn't the only one who thought so. *People* magazine called me "Richard Pryor's funny girl." They said I had "the same wicked sense of mimicry and humor" as my daddy. I clipped that review and framed it. I remember thinking, *Girl, you are on your way!*

They say power corrupts, and I wouldn't know, because I've never had much power. But I had a little success that first year, and I can tell you unequivocally that success can also be pretty tricky. I had money in my pocket, and I felt invincible, and people who feel invincible can do pretty stupid things. Like drinking. And drugs. And acting way tougher than they are.

I found myself turning into a version of T. J. Jones, without the soft inside, and without the brains. But somehow, despite my foolish ways, I made it through two seasons on the show without any major fuckups.

I also went out and did what a lot of foolish young actresses do—I got myself a new pair of tits. It's kind of sad, really. I had a boyfriend at the time who talked me into it, but he didn't stick around to enjoy them.

Despite my foolishness, I did have one intelligent, adult thought. I was a big girl now, making real money, and I decided I should buy a home. I was also getting a little help from Daddy, who had set up a modest trust fund for me. The money wasn't enough to live on, certainly, but it was gravy—and it was certainly appreciated.

A couple of months after making this monumental decision, I found a house I liked in nearby Toluca Lake. I needed $100,000 for the down payment, however, and I went to Daddy, who assured me it would be no problem. In the end, though, for reasons I couldn't understand, he decided that he could only give me $10,000. Since I'd already made an offer on the place, and since my offer had already been accepted, I went through with the deal, and it was a struggle just to make the mortgage every month.

When my gig on *Head of the Class* came to an end, I was unable to make the payments, so I rented the house to a family. Unfortunately, I didn't bother to check their references, and they turned out to be professional con artists. This so-called family would move from house to house, refuse to pay rent, and wait for the owners to default on their mortgages, then snap up the property at auction and sell it for a quick profit.

I fell for the scam. Within six months, I'd lost the house and every penny I'd put into it. (I also lost my Porsche, which I wasn't going to mention, but in the interest of full disclosure I will tell you that it was one of the dumbest purchases of my life. You want to

know why I bought the Porsche? Because Robin Givens had one just like it. Smart, huh?)

Meanwhile, I was living with a boyfriend from hell, one of several, and I dealt with my unhappiness—and my lack of employment—by drinking more heavily and doing more drugs. I kept it under control, though, because I had to look all bright-eyed for my auditions.

Eventually, I managed to get a guest spot on *Kids, Incorporated*, a children's show, and I also got the lead in *Frog Girl*, an ABC After School Special. It was about a girl who refused to dissect a frog in biology class and how her decision resonated through the community. It was not a great movie. One reviewer described it as follows: "This is the total dregs of the pretentious, morally patronizing 'let's deal with a controversial social issue in a very melodramatic way' style of television movie."

I was crushed, but not destroyed.

My next job took me all the way to San Diego, where I got a small part in a production of the rock opera *Tommy*. I was an understudy, alas, and never got a chance to strut my stuff. When I got back to L.A., one of my high school teachers cast me in a short film, *Black Bird Fly*, as a girl who gets molested by her father. The father was played by Garrett Morris, who'd made a name for himself on *Saturday Night Live*, and Whoopi Goldberg played the teacher who eventually comes to my aid. The film got excellent reviews, and even won some kind of award, but I don't believe it was ever released theatrically.

Suddenly, Rain Pryor was unemployed all over again.

As my self-esteem suffered, I developed a fear of auditioning,

mostly because every time I auditioned my self-esteem took another beating. *You're very talented, but not right for the part. You're very good, but we want a different look. You can act, but the character we have in mind is more attractive.*

They all noticed my tits, though, and I noticed them noticing, but nice tits didn't make me right for the part. I remember auditioning for the role of *Aida*, Verdi's famous opera, and being told by the casting director, "Honey, the role is for a *black* woman."

So, *again*, I wasn't black enough. Or Jewish enough. Or tall enough. Or short enough.

The weeks turned into months and the months turned into years. One morning, I woke up and realized that I was twenty-three and damn near unemployable, and that my tits weren't going to get me a job.

I didn't know what to do with my life. I was directionless, and I was broke, but I was still desperate to be an actor, and I did what a lot of actors do: I refused to consider a job in the *real* world. Like them, I wasn't ready to let go of the dream. I didn't want to take a part-time job to tide me over, because I knew too many people whose part-time jobs had become their full-time lives.

At one point, I met a young director who wanted to stage an avant-garde version of the play *Joan of Arc*. He thought I was right for the part, but he had no money, so I called Daddy. I was trying to explain why I wanted to do this, and why it was so important to me, and he cut me off. "No sweat, baby," he said. "How's twenty thousand dollars sound?"

It sounded motherfucking great!

In return, all Daddy wanted was a front-row seat to the premiere.

My father was never generous with his compliments, but the fact that he was willing to finance the venture said it all: he believed in me. He was willing to bet on my talent. Needless to say, I was over the moon.

I asked my half sister Elizabeth to help produce the play, along with another friend, Pam Goodlow. We worked our asses off, and staged it at the Globe Theatre, in West Hollywood. The *Los Angeles Times* made it a Pick of the Week, and the reviews were uniformly solid. I was walking on clouds.

*And absolutely nothing happened.*

That's the actor's life. You have a little success early in your career and convince yourself that you've got a future. You never stop to think, *I've got to hang on for the next forty years!*

That's something beginning actors don't understand: one job does not necessarily lead to another. An acting career is more of a gambling habit than a true career. You get lucky once, and maybe it happens again, but ten years later you're waiting tables and still looking for the big break. It's brutal, but you continue to believe, because that's the only thing that gets you out of bed in the morning.

*I believe in the dream.*

I was having a hard time believing, though, and I guess it showed.

"Rainy, girl, how you doin'?" It was Daddy.

"About the same. You?"

"Oh, you know me—hanging in." He always said the same thing. The MS was already beginning to manifest itself in small ways—muscle weakness, loss of some motor skills, numbness, blurred vision—but it hadn't hit him hard yet. "How'd you like to go for a ride with me and Brandy?" he added.

Brandy was his current girlfriend. I went out to Parthenia Street. Daddy and Brandy and I got into the Rolls Royce, and off we went. We were tooling along Highway 101 when suddenly Dad started yelling, "My leg! My leg! I can't feel my goddamn leg!"

I started laughing—I thought he was doing one of his routines, just trying to cheer me up—but it soon became apparent that he wasn't screwing around.

Brandy had the presence of mind to reach over and put her foot on the brake, and helped guide the car onto the shoulder. The three of us sat in complete silence for an entire minute, then Daddy laughed, and we joined in. We laughed till we cried.

Finally, Daddy opened the door and got out, with traffic whizzing past. He was a little unsteady, but he was getting the feeling back in his leg. Slowly, he made his way around the front of the car and approached the passenger door. Brandy slid behind the wheel to make room for him. Daddy got in. "That was pretty goddamn freaky," he said.

Brandy drove us home in silence. I could see Daddy's profile from where I was sitting. He looked humiliated and frightened.

As it turned out, he had good reason to be frightened. From that day forth, things took a noticeable turn for the worse. Within months, he had lost some mobility in his legs and in his hands, and before long he was using a cane—at least in private.

Like all actors, however, he believed. He believed he would get better. He believed his body would not betray him.

He believed with such faith that later in the year he went to work on *See No Evil, Hear No Evil,* with Gene Wilder. I went to visit him on the set, and it was painful to watch. He had trouble walking, and his speech was slurred. He couldn't even remember

his lines, and we're not talking Shakespeare here, people. Sample dialogue: "I hear prison isn't so bad if you like it up the butt."

The disease was really taking its toll, but Daddy didn't want to believe it was that bad, and I didn't want to believe it either. I guess I was in denial. I was watching him deteriorate and not seeing it. I was an actor, too, after all, and I would only believe what I needed to believe.

After that shoot, Daddy suffered a heart attack, his *second*, and had triple bypass surgery. Being sick really pissed him off, but it woke him up, too. He decided he should try to work on his health. Before long, he had hired a personal trainer, and he filled the house with running machines, exercise bikes, and training equipment. I don't know that he used them much, but they were nice to look at.

I remember Flynn came by to help him out, and she urged him to give up his cigarettes and booze. He cut back some, but only some, and tried to make up for their absence with hookers. Flynn called the hookers for him, and she did it with a sense of humor. "What do I care?" she said. "We're not married anymore. And do you really think he can still get it up?"

Jennifer Lee also came by, and for a brief period she was actually running the show. I hated the way she was always turning up—a genuinely *evil* version of the bad penny—but I had no say in the matter, and my father only ever listened to himself and his demons.

One day I arrived at the house to find my father lying in a heap on his bed, motionless, staring at the ceiling. There was a shattered wine glass on the floor, and wine stains halfway up the wall. He'd been in an argument with Jennifer, and it had left him completely depleted. That's when I first discovered that there's a huge emotional

component to MS—that stress can bring it on with a vengeance. I had never seen my father like that: he looked like an empty shell—a hollowed-out version of his real self.

I went over to the bed and whispered, "Daddy, I can take care of you. Please let me help you."

He shook his head but didn't look at me. I didn't understand it. I was giving him a chance, but he wouldn't take it.

"Daddy, please let me help you," I repeated.

"No," he croaked. "Just leave me here."

I don't know why he stayed with Jennifer. Maybe it was the make-up sex. Anyone who has ever been in a volatile relationship will tell you that it doesn't get much better than make-up sex.

For a time, because of Jennifer, I avoided visiting my father, and during this period she actually managed to drive a wedge between us kids by saying we were only after his money, and that we talked trash about him behind each other's backs, and before long none of us were speaking.

Then one day—thank you, God!—Jennifer was gone, and two of the ex-wives, Deborah and Flynn, began making regular visits to the house to help. Within a year, though, Daddy was in worse shape than ever, and drinking more than ever, so in 1992 he agreed to do a brief stint at the Sierra Tucson Rehabilitation Center, in Arizona. I went out to visit him on Family Weekend, and he was as emotional as I'd ever seen him.

When we had a moment alone, he turned to me and said, "I'm so sorry, Rainy. I'm sorry I hit you when you were little, and I'm sorry I did drugs in front of you and made you worry so much. I'm sorry about the hookers, too—I'm sorry you had to see that.

And I'm sorry I was always beating women up around you. I wasn't much of a daddy."

"That's true, but you're the only one I've got, so I'm stuck with you."

He gave me a little Willie Winkie teddy bear as a present. It was kind of odd, because I was a grown woman by then, but I think he was giving it to the little kid in me—the little kid he'd neglected. It was his way of making amends.

A couple of other women made the trip out to see him. One of them was Marilyn, his secretary at the time, and the other was a woman named Tina, who told the hospital staff she was his cousin. She was no cousin—she was a hooker—and I guess having a prostitute around for Family Weekend brought back all sorts of wonderful childhood memories—the good old days, when as a child he'd been surrounded by doting whores.

The man was incorrigible. He was never going to change.

When I got back to Los Angeles, I realized I needed to clean up my act, too. I wasn't a terribly serious drinker, and I seldom did drugs to excess, so in that sense I wasn't like my daddy. But I came home feeling scared and lost, for him as well as for me, and I decided that I should try to make some changes.

The fact is, I was still very confused about who and what I was. I didn't have much of a foundation, and I'd been such a chameleon all my life that I didn't know where the real me was hiding. My upbringing only further confused me. Whenever I'd been with Herb and Bunny, they'd talk to me about Passover, and about the meaning of Yom Kippur, and Bunny would cry on Fridays, when she lit the candles. When I was with Mom, I heard about the power of

crystals, and about the power of meditation, and about the power of mind-control, and about every other harebrained scheme that came down the pike back then.

Daddy's influence only added to the confusion. At different stages of his life he was a Baptist, a Christian, and a Muslim, but never actually *practiced* anything they preached. He once told me he believed in some kind of Higher Power, but he'd be damned if he knew what it was. (And it wasn't being all that good to him lately!)

So, yes, I was a bit of a lost soul. Over the years I had dabbled in a bit of everything. I visited synagogues and churches and Hindu temples. I tried my luck at a Tony Robbins seminar. I took the Course in Miracles. But nothing really worked for me because I didn't know what I was looking for. I guess I was looking for Some Answers, like the rest of us, but they were elusive.

Finally, I tried a 12-step meeting near my house. I liked the fact that they didn't pretend to have all the answers, and I especially liked the fact that I was supposed to get through things *one day at a time*. That worked very well for me. The day I walked out of that first meeting, I felt somehow *lighter*. If I only had to get through the day, I could manage it. It's when I thought of my entire goddamn life that things got complicated.

It was a good start. And I left there thinking that I was going to be okay.

Of course, a few meetings into it, when it was my turn to speak, my insecurities brought the chameleon back to life. I wanted to belong. I wanted to be just like all the other people there—I wanted to have the same problems they were having so that they would see me as a kindred spirit and not reject me. To that end, I put my acting

skills to good use. These fine people talked about their struggles with alcohol, so I talked about my struggles with alcohol. These fine people talked about blackouts, so I talked about blackouts. These fine people talked about cocaine binges, so I talked about cocaine binges.

It was all bullshit, of course. Bullshit fueled by insecurity. And I feel bad about it now.

In time, though, I came to terms with the bullshit. My problem was quite simple, really. There was no there there. I had no center, no personality, no identity. I had been so emotionally damaged as a child that I wanted to be anything and anyone except the little girl I was, and I had managed to drag those feelings with me into adulthood.

That's what had turned me into such a chameleon. All my life I just wanted to be loved and embraced, and I worked hard at becoming lovable and embraceable. I had done it in kindergarten, in grade school, and in high school, and I was doing it still. I even did it with the men I dated. If a guy was into heavy metal, I was into heavy metal. If he liked Rollerblading, I *loved* Rollerblading. And if he wanted to get stoned every night, that was my dream, too—to sit there and get stoned with him, night after night, for the rest of our days. Hell, if it made him like me better, I goddamn *lived* to get stoned.

The 12-step program didn't help me stop drinking, and it didn't help me quit drugs, because the real me didn't much like drinking and didn't really care for drugs. But the program helped me in much more significant ways. It taught me to listen to myself. It taught me to look within and sit in the dark with my thoughts and work on getting to know the real me. And you know something? I began to like what I saw.

As a child, I had been made to feel as if I had no value, and I'd been deeply affected by that. But I'd come pretty far on my own, despite all the shit, and that was certainly something to be proud of. I figured the Real Me could probably take me even farther. I really *was* like a lot of the people in that room. I'd been lost, but I was beginning to find my way.

I kept a notebook, and in the days and weeks ahead, per their suggestions, I recorded my goals:

> *To enhance myself spiritually*
> *To teach*
> *To advise*
> *To always keep learning*
> *To love*
> *To live*
> *To keep a positive attitude when things appear gray*
> *To let go*
> *To allow myself time*
> *To not judge*

Unfortunately, as I was improving, feeling stronger day by day, my father returned from rehab in Tucson and continued to deteriorate.

Elizabeth and I went over with a cake that first weekend, to celebrate his sobriety, but he was back on the bottle within weeks. The man had an iron will, but he used it for all the wrong reasons. He would *demand* alcohol until the people around him were too afraid to say no. He would *demand* cigarettes. And would *demand* whores.

Before long, some of his weak-willed hangers-on were coming over with drugs. Daddy could be very convincing. *Do this for me, baby, would you? Just one last time. I'm a sick man. I don't have much to look forward to. I love you, baby. You are the best thing that ever happened to me.*

The man was impossible, but I guess it was part of his charm.

Throughout this entire period, I was still trying to make it as an actor, of course, and I kept telling myself to believe. *You gotta have faith, Rain. You don't have faith, you won't make it. Rejection is part of the business—maybe even the biggest part of the business. If you don't believe in yourself you'll never know what you could have been.*

Even when I ended up working with a highway construction crew, holding up the SLOW sign for thirty-five bucks an hour, I believed.

And even when I was sitting on the beach in Venice, with a card table and two folding chairs, doing tarot readings for tourists (with the vast knowledge I'd picked up from Mamma!)—I continued to believe.

And when I got a job answering phones for a psychic hot line, with the *least* psychic bunch of people I'd ever met in my life, I still couldn't help myself—I genuinely believed I'd act again. Meanwhile, though, I owed it to my employer to be the best psychic I could be, so I believed I was a psychic. And I was pretty good at it, too. People were sad and depressed and they were paying $3.99 per minute to talk to me, and I honestly wanted to do something for them, so I put everything I could into it. I told them that they were probably *not* going to win the lottery; that someone was going to offer them a job and that it wasn't a great job, but that it

would lead to better things; that they needed to be honest with the people they loved; and that they had to love their children more than themselves.

I had people crying on the line. I felt good about it, too. If they were going to pay $3.99 a minute, which was about what they'd have to pay for a good therapist, they might as well get some real help.

At the same time, I kept wondering: was this it for me? Had my part-time job become my full-time life?

That same year, 1993, while I was worrying about my uncertain future, Dad received a star on the Hollywood Walk of Fame. Academy Award–winner Louis Gossett Jr. and composer Quincy Jones were among the hundreds of people in attendance, and both of them spoke at the brief ceremony. Gossett said my father had made it possible for blacks to break into Hollywood, and Quincy Jones described my father as "a pioneer . . . who made us understand the truth about us."

It was very emotional for me. The MS was slowly but surely taking its toll, and my father knew his days were numbered, but nobody could take his accomplishments away from him. He was a man who had made a real difference in the world.

Then there was me.

What had I done?

What difference was I making?

Why did I even exist?

Opposite: Dad receiving his star on the Hollywood Walk of Fame

# 10.

# WEDDING BELLS

One day, still slaving away at the psychic hot line, the owner of the place discovered that I was Richard Pryor's daughter, and that I'd spent three years on *Head of the Class*. He was deeply impressed. I was a celebrity (or a celebrity's daughter, anyway), and I was a genuine actor, too. He asked me if I would film a commercial for the psychic hot line, and I was glad to oblige. I was handsomely paid for my services, and shortly thereafter I decided it was time to move on.

I kept trying to audition, with limited success, and in 1995 I found myself in a sparkling clean hospital, pushing my father's squeaky wheelchair down a pristine hallway.

"I have MS," Daddy told one of the doctors in a shaky voice, cocking his head to one side. The doctor spoke to us about a surgical procedure, which was still in its experimental stages, and said it was risky, but that it might help him walk again.

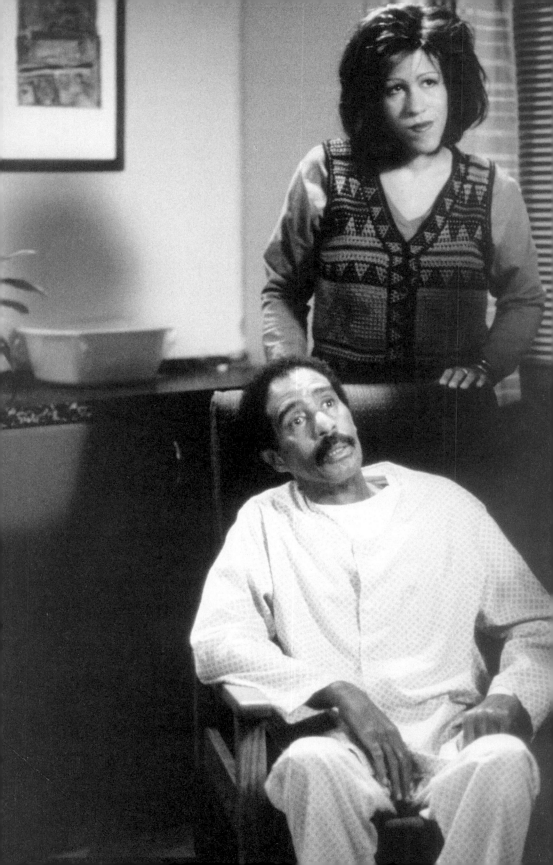

As I was listening, I noticed that the doctor was unusually handsome, and then I looked around and realized that *all* the doctors in the room were unusually handsome. It felt like a dream, but it wasn't a dream—it was an acting job: Dad and I were appearing together on an episode of *Chicago Hope*, the medical drama. It was the first and only time I ever acted with my father. He played an MS patient, and I played—big surprise!—his daughter.

I didn't have to fake those tears when I watched Daddy struggling to walk and talk. He was really struggling, and those were real tears.

Daddy was nominated for an Emmy as best guest actor in a drama series, and I didn't have to fake those tears, either. I cried when he was nominated, and I cried again when he didn't win.

From month to month, he kept getting worse, and at that point he knew there was no turning back. Since there was really nothing to be done, he became sort of fatalistic, and began drinking martinis in the afternoon—starting earlier every afternoon. Even when he began to lose his ability to swallow, he'd mix them up with a potion called Thick-It, and he somehow managed to get them down.

Every time I went to see him—and I went to see him often—he had deteriorated further. Whenever he tried to get out of his wheelchair, his legs shook violently, and he couldn't even manage a step or two on his own. Then even his voice started to go. There were days when he could barely croak out more than a word or two, and even those were barely audible, and other days when he wouldn't even bother making the effort.

Opposite: Dad and I in *Chicago Hope*, 1995.

Sometimes his mind would suddenly drift off, and it would feel as if he wasn't even there. Then just as suddenly he was back.

"Where'd you go, Daddy?"

"What do you mean?"

"I don't know. You drifted off for a few moments there."

He'd shake his head—not wanting to talk about it, exhausted by the effort—and I would drop the subject.

Between visits, I was actually finding a modicum of success on television. I got to play a lipstick lesbian on *Rude Awakening*, a Showtime series, and people began to assume that I was a lesbian. (Not that there's anything wrong with it, but I'm not.) My costars were Sherilyn Fenn and Lynn Redgrave, and I had a good run, until the day my character overdosed and died.

Ironically, while I was playing a junkie-lesbian on TV, my boyfriend at the time was a real-life junkie. I didn't know it then, probably because I liked him and didn't want to know it, and for a while we had a good time. He was funny and smart and charismatic and we ended up living together, and when I finally found out about the drugs—he'd left a used syringe in the pocket of one of his jackets—I didn't have the heart to throw him out. I tried to help him break the habit, and I even tried to help him get into show business, but he only succeeded in alienating my few contacts, and in due course his anger and frustration drove us apart.

After *Rude Awakening*, I was unemployed again, and the business seemed tougher than ever. One casting director suggested that I have my jaw broken and reset. "It'll make you look more feminine and less like your father," she said.

Another one told me that I looked like Richard Pryor in drag.

I thought my father was pretty cute, but that still hurt.

That year, 1998, my cute but ailing father won the inaugural Mark Twain Prize for American Humor from the John F. Kennedy Center for the Performing Arts. According to the press release, "Richard Pryor was selected as the first recipient of the new Mark Twain Prize because as a stand-up comic, writer, and actor, he struck a chord, and a nerve, with America, forcing it to look at large social questions of race and the more tragicomic aspects of the human condition. Though uncompromising in his wit, Pryor, like Twain, projects a generosity of spirit that unites us. They were both trenchant social critics who spoke the truth, however outrageous."

So what if I looked like Richard Pryor in drag? He was my daddy, and I was proud to look like him.

A few days after the ceremony, I went over to the house to congratulate him. Gave him a big hug, too. "I'm proud of you, Daddy!"

He looked up at me, his voice weak, his head cocked, and said, "I'm proud of you, too, Rainy."

It was all I could do not to burst into tears. I don't know why he was proud of me. I had accomplished nothing, and my prospects as an actor were looking increasingly dim. I was sick of auditioning, and I was seriously thinking about quitting show business. Trouble is, I didn't know what else to do with my life.

Then in 1999 I caught a small break, landing the part of a Who in *How the Grinch Stole Christmas,* the Ron Howard movie. They sent all of us Whos to train for our roles with members of Cirque de Soleil, and it brought back memories of my mother's short-lived attempt to turn us both into clowns.

Jim Carrey played the Grinch, as you probably remember, unrecognizable in that outfit and under all that makeup, and he was a huge fan of my father's. Unlike most actors in Hollywood, who are not known for their courage, he always asked after his health. "I love that guy," he told me time and time again. "Please send him my best."

The shoot was exhausting—costumes and makeup took several hours every day, and the day started at 3:00 a.m.—and the effort didn't exactly pay off. Most of my scenes ended up on the cutting room floor, so I had absolutely nothing to add to my actor's reel.

I had no job, no prospects, and no money. And I'll tell you this, when it came to money, I was a complete mess.

Everything I learned about money I learned from my daddy, and everything he taught me about money was probably wrong.

In the 1980s, when he was the highest paid black American entertainer in the country, if not the whole world, the money flowed as freely as the drugs and booze. Dad didn't give a shit about money. I'd seen him put five thousand dollars in cash into the outstretched hand of a hooker because she had asked for it nicely. "There you go, girl," he said. "Buy yourself something pretty."

That was my daddy all the way. You caught him in the right mood, you got what you wanted. And everybody tried. From his ex-wives and sometime-girlfriends to the hangers-on that drank his booze and snorted his coke, the question of money was always in the air. I didn't like it at all—it made me very uncomfortable—and I seldom asked for anything. Once, though, when I was in terrible financial trouble, I drove over to the house and explained that I needed his help. But I guess I caught him at the wrong time. He

had just finished doing business with a couple of hookers, and he didn't have any cash on him. "And you know how it is girl," he said. "My business manager's got my checkbook."

Yeah, I knew how it was. Everybody wanted a piece of daddy, and everything was a transaction, and if he wanted to make it hard on you, he made it *hard*. Plus who was I to complain? I had that trust fund, and maybe it wasn't enough to cover the rent, but it was a lot more than most people got. I had no right to ask my daddy for anything. Let the assorted hangers-on hit him up for everything they could; Rainy don't play that game.

"Why you love me so much, Rainy, when I can be so mean?" he asked me once.

"Because you're my daddy, dude. I'll always love you."

Of course, like every young woman, there comes a time when someone comes along to replace her daddy, and that happened to me early in 2000.

After another long stretch as an unemployed actor, I trained to become a drug counselor at a Jewish rehab center run by a very hip rabbi. Unlike a lot of religious leaders, he was all-embracing, and he told me that I should never think of myself as "only half-Jewish." He gave me a foundation on which to build my identity—the strength to start becoming the woman I am today—and, as a bonus, trained me as a drug counselor.

I parlayed the experience into a good job at a rehab center in the San Fernando Valley, just outside Los Angeles, and I began to focus on my new career. But good things happen when you least expect them, and a very good thing happened. . . .

His name was Kevin. He had a Bachelor of Arts in communications and theater arts, and he had started out as an actor, too. By

the time I met him, though, he had grown tired of scraping by, tired of starving between gigs, and he got certified as a drug and alcohol counselor. Then, to nail it, he went off and got his master's degree in marriage and family therapy.

When we first met, I assumed—for no good reason—that Kevin was gay. He was tall, with olive skin and a beautiful head of thick hair; he was in great physical shape; and he dressed beautifully. Now, if that's not *gay*, I don't know from gay.

We saw each other in the office every day, five days a week, and I would have fallen for him in a second, but my misguided suspicions about his sexual preferences told me to keep my feelings at bay.

Some months later, when, ironically, I'd already accepted him as "just a friend," Kevin and I were asked to become relapse prevention specialists. The training program lasted several weeks and was held in Pasadena, about forty-five minutes from the office, so we ended up carpooling to save on gas. Kevin had the nicer car, with a working air-conditioner even, so we went in his, and he would pick me up every morning with hot coffee and vanilla creamer. At that point, I absolutely *knew* he was gay. I mean, really—what kind of straight man is that thoughtful?

During the training sessions, several people assumed that we were a couple, which I found sort of amusing. But I was curious enough to ask Kevin about his life, and when I asked him, well—he wasn't even *remotely* gay. Not only that, he wanted to know what I was doing the following Saturday.

When he came by to pick me up Saturday night, he was wearing blue jeans, and he looked really hot. I had never seen him in anything but slacks and dress shirts, and he looked fine as a "suit,"

but he looked even yummier in casual dress. I can't remember what I was wearing. I can't remember where we ate. And I can't even remember what movie we went to. All I remember is that good-night kiss, and the way it curled my toes.

I immediately called my mother. "I met a really nice guy. He's handsome, super intelligent, polite, makes a good living, dresses beautifully, and has a car with air-conditioning," I told her.

She was speechless.

As we got to know each other, Kevin started looking even better, and three months later I finally took him to meet my mother.

Reader, she was bowled over.

"The guy is perfect," she said when she called me the next day. "I hope he's everything he seems to be, because from where I was standing it looks like the man's in love with you."

The following month, Kevin took me away for the weekend, to Montecito, a beautiful little town on the coast, about a hundred miles north of Los Angeles. Kevin had booked a room at the Montecito Inn, which was once Charlie Chaplin's weekend getaway, and when we arrived he ran a bubble bath for me.

After the bath, he took me for a sunset walk on the beach, and I noticed that he seemed really nervous. My first thought was, *He's going to propose.* My next thought was, *He's going to dump me and wants to do it in a classy manner.*

Just as the orange, orb-like sun began to slip into the water, Kevin stopped, turned to face me, and took both my hands in his. "This is where the ocean meets the sand, where two bodies become one," he said, his voice shaking. Then he fell to one knee and pulled out a little red box. He opened it, and I saw the diamond ring inside, tucked against the blue felt. I couldn't breathe.

"Rain," he said, taking a deep, bracing breath. "Will you please be my wife and spend your life with me?"

"Yes," I said, bursting into tears. Yes, I will."

Kevin kissed the tears away, and I tried on the ring.

I felt as if my life had just begun.

When we got back to Los Angeles, I immediately shared the news with my family. I took Kevin out to meet Dad, who greeted him in his wheelchair, and who subsequently took me aside to tell me he approved. "You done good, Rainy."

Kevin met my grandparents, too, and Herb regaled him with

Designer Anthony Franco fitting me for my wedding dress.

stories about old Hollywood, and about Danny Kaye, his favorite client. Bunny cooked another extravagant meal for us, and maybe for the first time it occurred to me that—despite the meshuggas—my grandparents truly loved each other. I guess Herb must have been reading my mind. "You should have seen the letter I wrote your bubbie when I was trying to get her to marry me!" he said.

"He was very romantic!" she agreed.

"Sixty years we've been together, and we never fight."

"Now he's exaggerating," Bunny said, but she said it with love. "When he gets angry, he's a terror!"

My wedding day

"I never cheated on her once!" Herb said.

"No you didn't," she said. "And it's a good thing, because if you had, you'd be dead."

Kevin and I were married by a friend of Kevin's—a gay, Jewish judge—and held our small, half-Jewish, half-Catholic wedding at the home of another friend. We read from the New Testament, and performed the service under a chuppah, and we had written our own vows. I got a big laugh when I said that I'd been working on a special list for many years—my requirements for a husband—and that I had been forced to marry Kevin because he met every single one of them, and then some.

When the ceremony was over, Kevin smashed a glass with his heel, per Jewish tradition.

I had wanted my father to walk me down the aisle, even if it meant pushing him in his wheelchair, but he said he preferred to sit quietly with the rest of our friends and families, because he didn't want to take the attention away from me. He was also pretty sick by this time, and I'm sure he didn't want to be on display.

I asked my grandfather to do the honors, along with Melvin van Peebles, who'd been a friend of the family since before I was born. It was nice to have him there, and it was nice to have Grandpa Herb there, too, but I hardly looked at them: I looked at my father throughout the whole ceremony.

A few days after the ceremony, before we left on our honeymoon, my mother gave me my trousseau. It consisted of the few nice dishes she'd manage to salvage from the marriage, along with that fur coat my father had given her when he was trying to make amends for his horrible behavior. The coat was moth-eaten and

looked pretty ratty. "You could make a pillow out of it," my mother joked, but she had tears in her eyes.

Kevin and I honeymooned in Hana Maui, where I'd spent so many vacations with Dad, and we stayed in the same hotel, near the old house, which he had since sold. Hawaii had always been a magical place for me, and having Kevin there to share it with me—and to see my old childhood haunts—made it even more magical.

I felt free to be myself with Kevin, and I loved him all the more for it. When we got back to Los Angeles, Kevin encouraged me to pursue my dreams. Without Kevin, I would never have had the

Kevin and I opening our wedding presents after the honeymoon.

courage to produce my solo show. Without Kevin, *Fried Chicken and Latkas* would not exist.

In many ways, I felt that in his heart Kevin still dreamed of performing, but he deferred to me—he let my dreams come first. He said he would support me until I got on my feet as an actor, and that at that point he might begin to take another look at his own future.

I felt like the luckiest girl in the world, and I told him I would be eternally indebted to him for his generosity.

Here's a little taste of the result—from my play, *Fried Chicken and Latkas*:

### RAIN

Hello! How is everybody? I am so glad to be here. I almost didn't make it because I saw a sale. And being the good Jewish woman that I am, I'm not about to pass up a bargain. The store was the bomb fo'shizzel. I threw down some sheckles on these fly-ass Puma kicks. I started to walk out of the store when I noticed some schmuck behind the counter staring at my tuchis. . . . I was like, Oh no! You must be some meshugene mothafucka. So I bounced!

### BERNICE

*(my maternal grandmother)*

Do I have any black friends? Well, we had that black maid once and we were friends. We were friendly. I paid her well. Then your mother, my shana madel, married your father. A black. You know, I didn't mind the two of them getting married, but did the neighbors have to know? Well, how could they not know with all the *meshuggas* going on. You know, we came home once in the mid-

dle of the night to find that the entire apartment was changed into the African Heritage Museum. A black velvet Jesus was nailed to the cross, his eyes were glowing in the dark, and I think . . . I don't know . . . okay . . . I'm *sure* I saw his shlong. I kid you not. And a black man's shlong is not something you want to joke about. Was I upset? I was fotootsed. The Star of David was being used for a game of Chinese checkers. You know, the Sixties were turbulent times. Our children were being sent off to war. Anyone who tried to lead the country wound up dead. And the blacks and the Jews were being blamed for everything. It was difficult to explain an interracial marriage back then, let alone the child from one. But one good thing came out of that, and that is you, my Rainflower—who happens to be half-Jewish and half-black. Or should I have said Afro-American? You know, I don't know with all the names those people have—they should take something from us. For six thousand years, Jews have been Jews. But enough of my kvetching. It's time to light the Friday night Shabbat candles. Why do we do this? We do this to welcome in the weekend by reflecting on what we have done during the week. But we try not to reflect too hard, because otherwise you'll get depressed.

## SAMANTHA

### (a "friend" from high school)

Oh my God! Oh my God! Oh my God, Rain! Your hair is so big! Ya know I can barely see the mirror through your big hair. Like, what do you keep in there anyway? Like, is it totally true that you people put plastic on your couches because you're afraid the grease from your hair might stain them? Like, I totally heard

that was true, totally. Like, okay, did you totally see Joshua out there looking at me? Oh my God! Like, what a babe! Umm, excuse me, Rain? You can't be serious? You like Joshua! Rain, he likes *Jewish* girls and like, duh, I'm Jewish and you're not. . . . No, you are not. Just because you know all the songs from *Fiddler on the Roof* doesn't make you Jewish. Besides, your mother would have to be Jewish in order for you to be Jewish. And I am pretty sure your mother isn't Jewish. Well, first off, Jewish women don't marry blacks and there are no such things as black Jews.

## WANITA
### *(my alter ego)*

Ready? Okay. My name's Wanita and I may be tall, but when it comes to sex, I give it my all. Hey, hey, hey. Who is the best? Hey, hey, hey. Wanita's the best. Hey, for real though. . . . Hello, girl.

What you staring at? This ain't the zoo. Okay, for real though. My name is Wanita, W-A-N-I-T-A Jackson J-A-C-K-S-O-N. You might wanna write that down. Yes, I can spell. Okay, for real though. Hey, hey, hey. Have you seen Rain Pryor? Well, you ain't gotta look at me like I'm stupid. Okay, for real though. I know she was just up here. But since she ain't here, let's talk about her. Okay. Ya know they be saying her daddy be Richard Pryor? Well she do look like him with the long chin and shit. Okay, for real though. And how come she always hanging out with them white girls? I see you trying to flick your head from side to side like you even got something to flick. What, she pass the brown paper bag test? Okay, for real though, don't get me started. Girl so bright, I need sunglasses just to see her. And she always with them white boys, too. But she did have her eye on that one shiny black boy. But shoot, he wasn't all the way black—he was blackanese. Dat's black and Chinese. Okay, for real though. But I give her credit because he was fine looking, like Prince, and Michael Jackson, when he was still black, and before he got his nose did. Okay, for real though. Girl, personally I ain't ever goin' out with no white boy. Hell, no! 'Cause my mamma would whup my ass, that's why. My mamma taught me all about jungle fever. Besides, I don't need no white boy telling me something like, "The blacker the berry, the sweeter the juice." Then he gonna break up with me anyway to go out with some white girl that'll make his mamma proud. You feeling me? Give me a dark chocolate brotha with some juicy Kunta Kinte lips and a tight fade and I'm all up in that. Okay, for real though. Don't get me started 'cause I'll be up in your business in a minute.

## MAMMA

### *(my paternal great-grandmother)*

Rainy baby, don't you ever let no white person call you a nigger. Them could be fighting words. You understand, baby? You is a Pryor. Now take your nigger ass on in the house and get ready for supper. . . . Now, I'm sure I done fucked up dat child's head from that moment on. Well shit. Girl needed to know who she is. If you black, you is a nigga in my house. The world see her as a nigga regardless of what her mamma is. So, nigga it is. Nigga is terms of endearment in our household. Like "Nigga, please!" or "Nigga, where you been at?" or "Don't fuck wit me, nigga, 'cause I'll stick my foot up yo' ass." Now go wash your hands, nigga, 'cause it's time for dinner.

# 11.

# THE PRISONER

Shortly after we returned from our honeymoon, I connected with my old business manager and again began making the Hollywood rounds. My father, meanwhile, continued to deteriorate, but even as he was falling apart he always tried to put a happy face on things. *Don't worry about me, baby. Everything's good. I feel fine.*

In early 1994, when Daddy was already beginning to find it difficult to walk, Jennifer Lee came back into the picture. Initially, this seemed like a good thing. I figured she still loved him, and that she had returned in an hour of need to do what she could to help. But by 2001 I started having my doubts about Jennifer.

When I was alone with my father, I expressed my misgivings about her, but he assured me that Jennifer was only there in the capacity of an employee—to help him manage his various business enterprises, and to juggle his increasingly frequent medical appointments—and that there was no emotional component to

their relationship. "That woman and I are ancient history," he told me. "She's just here to help."

So you could imagine my confusion when I was told by Jennifer that they had married in June of that year. I was crushed. Obviously, Jennifer had a real hold on my father, and this worried me.

As Daddy got worse, she began to take total control, and before long their roles were completely reversed. Now she was the one with the power, not Daddy, and it looked like that's the way it was going to be until the bitter end. Before long, I was informed that I couldn't simply stop by the house at my leisure, but that I had to schedule appointments in advance. Since I had never made any secret of my feelings for Jennifer, I wondered if she was simply going out of her way to make things as difficult as possible for me.

When I finally did make it over to the house, my concern over my father's health only increased. On one occasion, sick with worry, I went to see him with my half sister Elizabeth, to talk about the situation. He told us he was afraid, although he didn't say why, and I could see the fear in his eyes.

A week later, I went back to find him looking absolutely haunted.

"Are you still afraid?" I asked him.

"Yes."

"Then we need to do something about it, don't we?"

"What can we do?" he said, shrugging his shoulders helplessly.

"We can get you out of here," he said.

"No," he said "No. No. This is my home. I'm not going anywhere."

I began to wonder if he was playing games with me, or if his mind was playing games with him, and if these little dramas were somehow designed—consciously or not—to keep life exciting and

make him feel more alive. I couldn't imagine what it was like, sitting in that house, deteriorating by the day, waiting for the end.

Then I began getting unsigned letters telling me that I was causing my father undue stress and that I needed to stay away from him. I assumed they were from Jennifer, but she was still in control, so I couldn't confront her without the risk of being banished.

The next time I went to the house, Daddy refused to talk about the situation, and the staff seemed equally tight-lipped.

I came home one afternoon to find a message from a friend on my answering machine: *Have you looked at your father's website lately?*

I had not, so I logged onto richardpryor.com. The site was managed by Jennifer, so perhaps it shouldn't have come as a surprise, but I was completely floored by the hateful, ugly things she had written about me and other members of the family. She said that she, Jennifer, was the only person who truly loved Richard, the only one who cared enough to take care of him, and the only one who tended to his interests, and that the rest of us were simply out for ourselves.

"I am very sorry these girls didn't ever have a relationship with their father," she wrote in one posting, referring to us as "low-life bitches," then she went on to describe the "Herculean tasks" she performed on Daddy's behalf.

Within a few months, Richard Jr. sued Jennifer, unsuccessfully, for the right to become Daddy's conservator. He claimed that Jennifer was refusing to take proper care of him and had been misappropriating his money. Jennifer countersued and dragged me into it. I was deposed by a team of lawyers, and I told them that Jennifer had hired some good people to take care of my father. This was the best I could do without lying. The truth is, I wasn't

comfortable with her being in charge of Daddy's care, but she had the power to keep me from ever seeing him again, and I didn't want to alienate her.

After that experience with the lawyers, I called my mother to talk about it. "Everything is going to hell," I told her.

She wasn't particularly sympathetic. "Richard did this to himself," she said. "He let that bitch back into his life. If your father loved you, he wouldn't be putting you through all of this shit."

*Thanks, Mom. That really helped.*

At one point, shortly thereafter, Daddy took a turn for the worse, and he ended up in the hospital, on a feeding tube. I talked my mother into going to visit him with me because I wanted her to get a firsthand look at what was going on. Daddy didn't say much, though. He smiled and was pleasant and generally tried to put on a good show, but he wouldn't talk about his condition or about the situation at home. I don't know what I expected. He couldn't have talked if he wanted to.

Mom looked at me, then at Daddy, then back at me. She may have acted tough, but it was evident that she still had feelings for Daddy. "This is the best thing you and I ever did in our lives," she told him.

He looked over at me—I was trying not to cry, but the tears were already spilling down my cheeks—and nodded: *You got that right, Shelley.*

I had to leave the room to compose myself.

That was a big turning point for me and my mother, and today we are closer than we've ever been. I don't know what did it exactly, but we'd been through so much drama together that I guess we decided we'd had enough for several lifetimes. The only recent argu-

ment I can remember was about the writing of this book. "I wish you wouldn't do it," she said. "I'd like my private life to stay private. But what the hell, if you don't write it, somebody else will."

After that visit to the hospital, Daddy took another turn for the worse, and so did Jennifer. She made it increasingly difficult for anyone to schedule appointments, which, ironically, helped bring us kids back together. But there really wasn't much we could do; Jennifer was in control.

Then the tabloids got into the act, writing all sorts of stories about the various family feuds, all of them largely inaccurate.

I spoke to Elizabeth, I spoke to Deborah, I spoke to Flynn, and they were as upset as I was. I even talked to a private detective at one point, and he began asking some questions, but he seemed to be making little headway.

Kevin noticed that all the stress and worry was taking its toll on me, and he urged me to begin taking better care of myself. "You've got a career to pursue, remember? Please don't let this take over your life. It will destroy you."

I went to see Melvin van Peebles, who was shooting *Panther*, an independent feature, and he cast me in a small role. One day, while he was setting up a shot, he told me, "Rain, you're a talented girl. If Hollywood doesn't give you a career, create your own."

I broadened my horizons and landed a small role in *The Vagina Monologues*, which was being staged at the Coronet Theater. As a result of that performance, a friend invited me to do a cabaret show at his small, local restaurant. I thought of Wanita, again, and of old Mamma, whom I'd been talking to in my head, as Daddy had done, and I thought of all the other crazy characters who existed only in my mind, and I invited them to perform with me. I

was a hit. Even my business manager was bowled over. "Rain," he said. "You've got to turn this into a solo show."

I sat down and worked on it, fleshing out the various characters, and I showed Kevin the result. He was so impressed that he took the script to a friend of his, and the guy ended up hosting a backer's audition at the Canon Theatre in Beverly Hills. Suddenly, Kevin was back in the business—as a producer.

More than forty potential backers showed up to watch the show, which became the basis for *Fried Chicken and Latkas*, and when the curtain dropped, I was given a standing ovation. People told me I was destined for Broadway and other, unimaginable heights, but within two weeks everything had fallen apart. No backers. No venue. No one-woman show.

Unbowed, Kevin and I decided to produce the show ourselves. We scraped together ten thousand dollars and took it back to the Canon Theatre, playing to sold-out crowds six weekends in a row. The *Los Angeles Times* gave the show glowing reviews, and a friend of Kevin's—a producer at CBS—got the network to do a story on me. Less than twenty-four hours after the segment aired, I had more than a dozen offers to perform in theaters across the country.

Kevin was now on board as both producer and manager, and he deserved to be, of course, but it created some friction for us. He was my boss, and I honestly didn't like it. I wanted the old Kevin back, the guy who loved me and supported me, not the one who was telling me how to write my show.

*Why is it so hard to get things right?* I wondered. *My love life was fine, and my career was in the toilet, and now my love life's in the toilet and my career is taking off. Why can't a girl have EVERYTHING!*

It was a tough time for us. We were still the same people we'd

been when we were married, but not exactly. Like other people, we had changed, and our needs had changed, and if we weren't careful these changes were going to tear us apart. I didn't want that to happen to us, but I began to find myself pulling away from him.

Within a year, I had taken the show on the road, and I was away from home three out of four days, so in a sense I had left the marriage. Kevin and I communicated, but only sporadically, and I poured my energies into the show. I loved performing, and I loved bringing my characters to life, and I especially loved bringing audiences to their feet. I also loved the fact that Jews embraced me as a Jew, blacks embraced me as a black, and that the rest of the audiences saw me as a Citizen of the World. . . . Funny, that's exactly what my mother had dreamed of when she first saw me. *My little biracial baby. My little peacekeeper. My little harbinger of things to come.*

Whenever I was back in Los Angeles, I went to see Daddy, of course, and I'd tell him all about the show. "I'm out there channeling Mamma night after night," I said. "And the audiences love her."

"Sort of like Mudbone," he said, his voice scratchy and barely audible.

"Yes," I said. "Sort of like Mudbone."

There was a difference, though: Mudbone had been Daddy's own creation, a composite of characters from his long-ago youth, while Mamma was real. But there were similarities, too. We were both channeling characters, bringing them to life onstage. Mamma had been his living, breathing grandma, yes, but—as they say in Hollywood—I was making her my own. It was Mamma's voice I heard above all others.

*I built dat whorehouse, the first of its kind in Peoria, 'cause I KNEW there was money to be made offa those white men. Ain't nothin'*

*wrong with giving up honey from the honey pot when whitey is putting cash on the table. Shit, he been stealing it all along, so it's time he began paying for it . . .*

*Yes sir, Richard Pryor—boy comes from a long, prestigious line of pimps, madams, and whores. I should know. I'm the one done raised his black ass. . . .*

Like Mudbone, Mamma told it straight. Like Mudbone, Mamma cut through the shit.

*Richie, Richie, Richie. He love dat pussy too much. Women—they gonna be the death of him.*

Mamma got *that* right for sure.

By this time, Daddy was so gone that there were days when he couldn't speak at all, so Elizabeth and I communicated with him by

With Dad and Elizabeth. He was always happy to see us and never wanted us to leave.

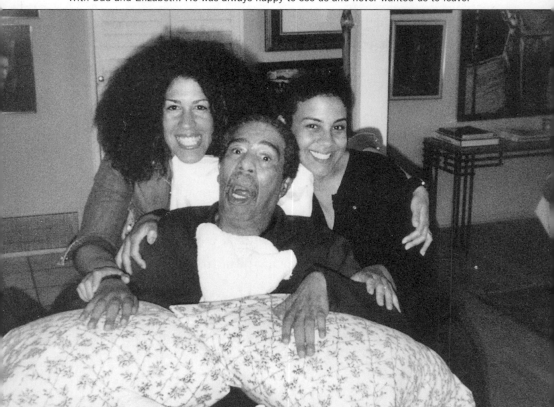

blowing kisses. We would say, "I love you Dad," and blow him a kiss, and he'd smack his lips and pucker up. He loved us, too, but there wasn't much left of him. He'd never been much of a dancer, but I remembered the man who could swagger and strut.

And God knows I missed that man.

At about that time, through the show, I met a man who was affiliated with a company that was working on a cure for MS. He told me that they were still a long way from a cure, but that they were doing their best, and he wondered if I would be interested in helping.

"Me?" I asked. "How can I help?"

"You can help us by making people aware of the disease. You're Richard Pryor's daughter, and an actress yourself. You could speak for him."

I was bowled over. He was absolutely right! I could become Daddy's voice.

That led to other meetings, and to still more meetings, and before long I was made "Lifelines Ambassador for MS." When I wasn't working on the show, I was flying across the country, talking about MS and helping raise money for research. My father was losing his voice, but I was doing everything in my power to stand up and make sure people heard him. *This is what it's like to have MS. This is how it destroys you, an inch at a time. Please help us find a cure.*

By the summer of 2005, Jennifer decided that I could only visit my father once a month, saying that the stress had become too much for him. When I showed up for my next visit, I found him in his chair, in his room, watching the Comedy Channel. He didn't look happy. I went to change the channel, but one of the caregivers

warned me against it. Jennifer doesn't like him to watch anything else, she told me.

"Why?"

"Because it's too stressful."

I wondered when Jennifer had become such an expert on stress.

I subsequently wrote a letter to Jennifer's attorney, Brian Colligan, outlining some of my concerns, and asking that we children be allowed to visit more frequently. "Mr. Colligan, your client Jennifer Lee has no legitimate reasons for keeping us away from our father," I wrote. Jennifer may have believed she was bringing order to his life, but I couldn't understand why it had to be at his children's expense.

Nothing changed. The next time I called to schedule a visit, Jennifer said I could see Daddy, but not at the house.

"I don't understand," I said.

"I don't think it's healthy, your coming here. You need to meet somewhere else."

She gave me the name of a hotel in the San Fernando Valley, not far from the house, and I met him in the lobby. He was in his wheelchair, with one of his regular caregivers. He smiled when he saw me, but he couldn't talk, so I did all the talking. I talked about my work for MS, and I talked about the show, and I talked about some of the problems at home, and then I was pretty well talked out.

I went back the following month, and the month after that, and then I went back one more time in November. I got to the hotel early and settled into a remote corner, so we could have a little privacy, and he arrived a few minutes later. He was wheeled into the lobby by one of his caregivers, and a second caregiver followed close behind, and the minute I saw him coming I felt the blood rushing to the back of my throat.

He was wearing one of those bizarre velour sweat suits you see on old men in Miami Beach, and I felt like saying, *Wait a minute! I'm the Jewish one, not you!* I checked the urge, though. I wasn't sure he was coherent enough to get the humor.

As he got closer, I noticed that he looked very bloated—his kidneys had begun to shut down, and he was on dialysis—and his face was so puffy that he was virtually unrecognizable. I looked into his eyes and he looked back at me. The eyes I still recognized, and I loved those eyes. He could smile with those eyes, and in fact they were smiling at me then.

"How you doing, Daddy?"

He didn't answer. I knew he wasn't going to answer, but you never give up hope.

"Daddy, listen to me, I know this is going to seem weird to you, but I went to see a healer yesterday, to talk about you, and he thinks he might be able to help."

He blinked his eyes. *I'm listening*, he was saying.

"He's a very gifted healer. A lot of people swear by this guy. He said he'd have to meet with you in person, of course."

My daddy shut his eyes, and they stayed shut for almost a minute. When he opened them again, I could see he was exhausted.

"Would you rather talk about this some other time?"

He didn't say anything. He didn't grunt. He didn't blink.

"You tired, Daddy?"

He nodded.

"You want to go home?"

He shook his head.

"You want to come home with me like I've been asking?"

He nodded.

"You want to live with me?"

He nodded again.

I fought the tears. "Daddy," I said, "listen close now. I'm going to make some calls. I'm going to try to figure out how to get you out of this situation."

He nodded and stared off into space. Maybe his mind was gone. Maybe I'd just been having a conversation with myself.

Then he conked out again, and his chin fell against his chest. I looked across at one of the caregivers, standing by on the far side of the lobby. She could see that I was very concerned, and she hurried over.

"Look at him," I said, fighting tears. "He can't even hold his head up."

Daddy opened his eyes.

"I love you," I said.

He tried to shape the words—*I love you, too*—but even his lips had betrayed him.

I watched as his caregivers wheeled him outside and lifted him into the van, then I got in my car and drove home, weeping all the way.

That was the last time I saw my father.

# EPILOGUE

On December 10, 2005, I was three thousand miles from home, in Baltimore, visiting friends, and I woke up very early. For some reason, I had an urge to listen to the Oleda Adams song, "Get Here," and I riffled through my friends' CD collection and found it.

*You can reach me by airplane*
*You can reach me with your mind—*

My cell phone rang and I lowered the volume and answered it. It was Flynn, one of the exes.

"How you doin', Rain? It's me."

"Hey," I said. "What's up?" But I already knew.

"I've got something to tell you, Rain, and I need you to be sitting down."

I sat down. I could hear my heart roaring in my ears.

"Your father had a heart attack this morning, baby. He's gone."

I don't know how I made it back to L.A. I vaguely remember some friends helping me dress, helping me pack, helping me through security at the airport, and helping me get on the plane.

The flight took five hours, and for five hours Mamma and I talked about Daddy, and about how much we both loved him, and about all the crazy things he'd done—*Daddy, the whores need to be paid!*—and how empty the world was going to seem without him.

Jesus. I missed him already. How could I go on?

*I can't go on. I'll go on. I can't go on.*

We laid him to rest at Forest Lawn.

The casket was closed, covered with sunflowers. A picture of Daddy stood on a small table next to the casket. He was smiling in the picture. I was sobbing.

The funeral had been planned by Jennifer. Few people attended. The service was void of meaning, but *Entertainment Tonight* showed up. (That's something, right?)

At one point, a tiny white woman went up to the podium and began to talk about Richard's life and legacy. The woman was a complete stranger to me, and her words rang false and hollow.

It was so unfair.

I broke down and wept, and my grandparents came over to comfort me, and Herb was so upset that he also burst into tears. "I'm sorry," he said, wiping his eyes. "I hate to see you in so much pain. I want to take your pain away."

In the day ahead, I went back and looked at all the stories in the newspapers, and that helped a little.

"Richard Pryor, the iconoclastic standup comedian who transcended barriers of race and brought a biting, irreverent humor into America's living rooms, movie houses, clubs and concert halls, died Saturday. He was 65."

—*NEW YORK TIMES*

"Richard Pryor, the outrageously raunchy and uproariously funny comedian and actor who defied the boundaries of taste, decency and race to become the comic voice of a generation, died yesterday at a Los Angeles hospital, where he had been taken after a heart attack. Pryor, who was 65, had been in deteriorating health for years because of multiple sclerosis."

—*WASHINGTON POST*

"Richard Pryor, the groundbreaking comedian who turned confessional profanity into poetry and brought the humor of black America to generations of fans, died Saturday at age 65."

—*DALLAS MORNING NEWS*

Neil Simon, the playwright, called him "the most brilliant comic in America." Eddie Murphy said "he was better than anyone who ever picked up a microphone." And Keenan Ivory Wayans told it straight: "Pryor started it all."

It didn't end there.

From Roseanne Barr: "Richard Pryor is the greatest stand-up who ever lived. He opened the biggest door and turned the light on in the room."

From Jim Carrey: "Some people are born wearing an iron shoe.

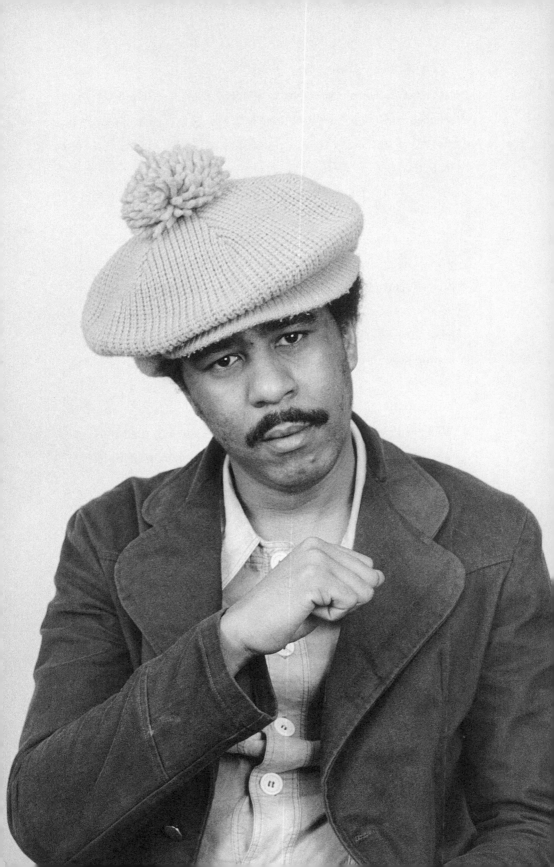

They're the ones who kick doors down and enter the places that before them have been untouched even by light. Theirs is always a mission filled with loneliness and broken bones. Richard Pryor is one of the bravest of them."

From Morgan Freeman: "There are some people who impact your life forever. Richard Pryor is such a person. It is un-defining to call him a comedian, for he seemed to transcend comedy when he spoke to us."

From Whoopi Goldberg: "There will never be another Richard Pryor. He is, and always has been, the funniest man alive."

From Martin Lawrence: "It sounds clichéd to say that he opened the doors for all of us, but it's true. . . . He did for comedy what politicians do for movements. He passed a law that said it was okay to tell it like it is."

From Lily Tomlin: "A gifted, raging, soaring, plummeting, deeply human man with a tender boy inside—the greatest pioneering comic artist of the last three generations."

Well, it's true—Richard Pryor was all those things and more.

But first and foremost he was my father.

I think of him and I miss him every single day, but I know he's up there, flirting with angels.

# ACKNOWLEDGMENTS

This book would not have been possible without the support and guidance of Cathy Crimmins, Susan Raihofer of the David Black Agency, Irene Webb, and Pablo Fenjves.

I want to acknowledge my mother, Shelley, for making magic after the pain, and my grandparents, Herb and Bunny, for showering me with love and giving me a sense of security when the world seemed out of control. My aunt Lorie, for just being there. Kevin, for being the first man to ever love me. Elizabeth, the best sister I have ever known. Richard Jr., for being in my life again. Franklin, for being so grown and allowing us all in. Steven and Kelsey, for opening up to the possibility that we can be a family. Renee, for coming back into our lives—you were never forgotten. Flynn and Geraldine, for bringing up some great kids. Mattie and Bob, for always being friends and never judging. Craig, Scotch, Peter, Fiona, Denise, Sunday, Kat, Mike Epps and Nile Kirshner, Gary Blumsack, Michael Garelick, Jill Garelick, Tom Rapier, Roberta

Hollander, and other important friends who stuck it out after my dad passed away. Marshak Zachary for hooking me up with Irene Webb. Suzie Deitz, Tom Rapier, Roberta Hollander, Michael McLean, David Friedlander, Brian Kabaznick, and Steve Traxler, for being the angels for *Fried Chicken & Latkas*. The National Multiple Sclerosis Society in the United States and the United Kingdom, for supporting my mission to find a cure for MS, and giving me and others hope.